KEY WEST

A Tropical Lifestyle

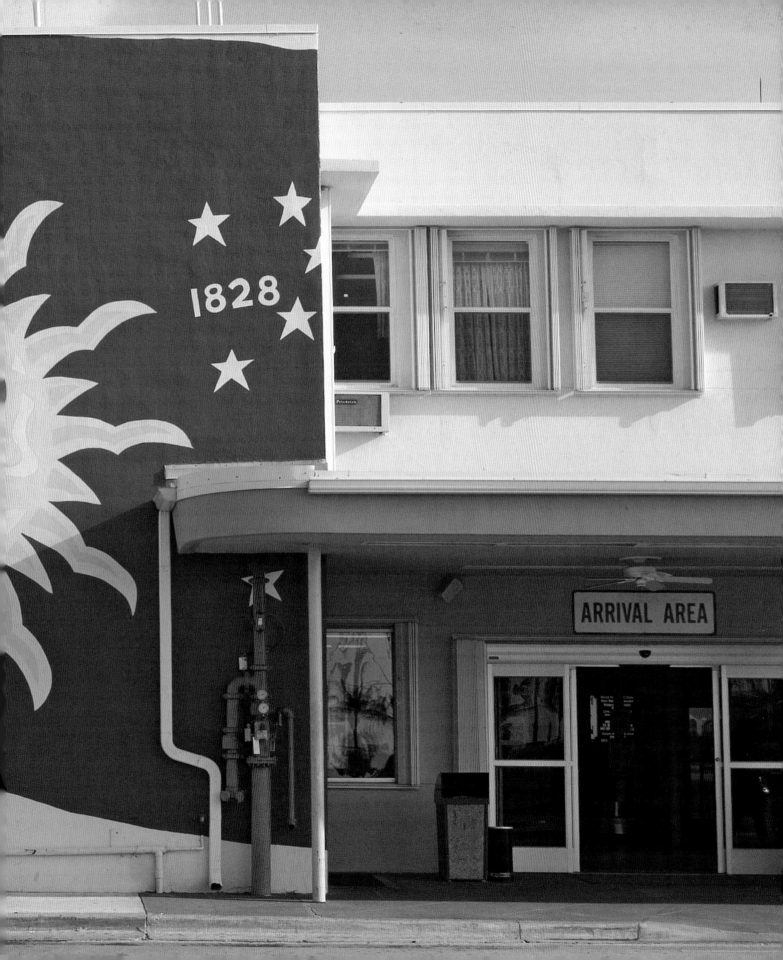

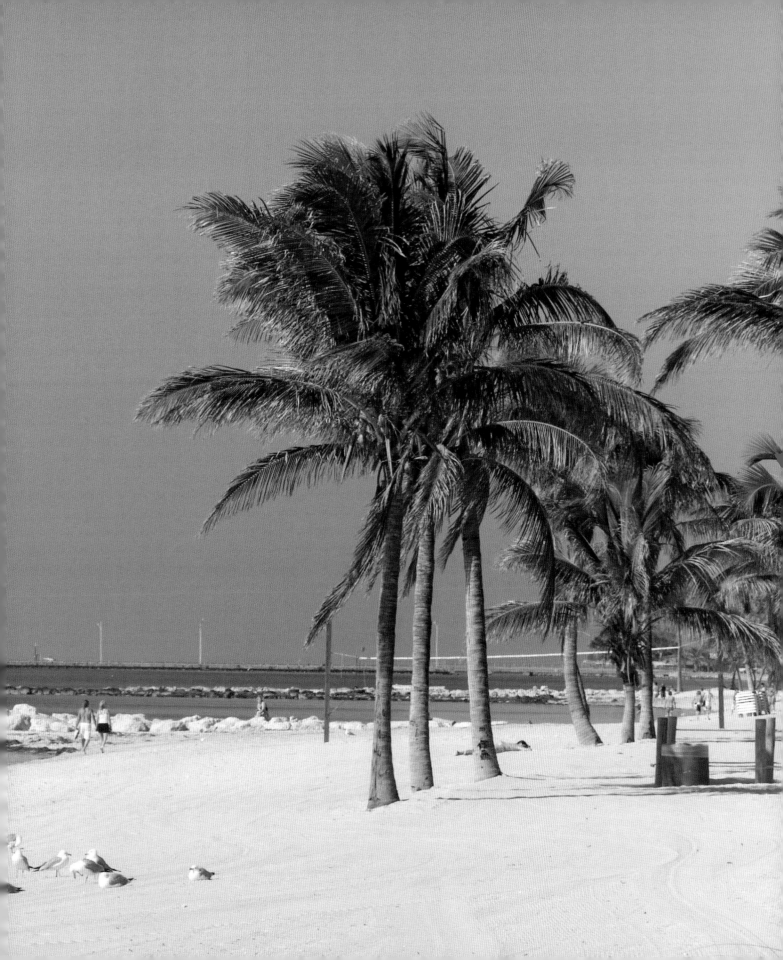

KEY WEST

A Tropical Lifestyle

Leslie Linsley

Photographs by Terry Pommett

THE MONACELLI PRESS

First published in the United States of America in 2007 by
The Monacelli Press, a division of Random House, Inc.
1745 Broadway, New York, New York 10019

Library of Congress Cataloging-in-Publication Data
Linsley, Leslie.
Key West : a tropical lifestyle / Leslie Linsley ; photographs by Terry Pommett.
p. cm.
ISBN 978-1-58093-197-7
1. Architecture, Domestic—Florida—Key West. 2. Interior decoration—Florida—Key West. 3. Gardens—
Florida—Key West. 4. Key West (Fla.)—Buildings, structures, etc. I. Pommett, Terry. II. Title.
NA7238.K48L558 2007
728'.370975941—dc22
2007018661

Printed and bound in China

Designed by Christine N. Moog, Little Spoons Inc.

Pages 2−3: The Conch Republic mural painted on the side of Key West airport terminal
is the first and last sign visitors see upon arriving or leaving the island.
Pages 3−4: Smathers Beach is a popular place for sunbathers, weddings, and parasailing,
along North Roosevelt Boulevard.

CONTENTS

11 Introduction

Old Town

31 Stately on Fleming
39 An Artist's Retreat
47 Classic Revival
57 A Garden of Art
63 Casual Entertaining
67 Living Large in a Small House
77 Apartment Living
85 A Step off Eaton Street
91 Side by Side
99 An Artist's Bungalow

The Meadows

105 Palm Meadow
113 Two for One
121 In the Classic Tradition

Casa Marina

131 Color Works!
139 Contemporary Casa
149 Southernmost Living
159 A Modern Interpretation
163 A House with a Past

New Town

169 Midcentury Modern
177 A Colorful Invention

Lanes

185 Down Schippens Lane
193 On Curry Lane
199 On Pinder Lane
205 My Secret Garden

211 Acknowledgments

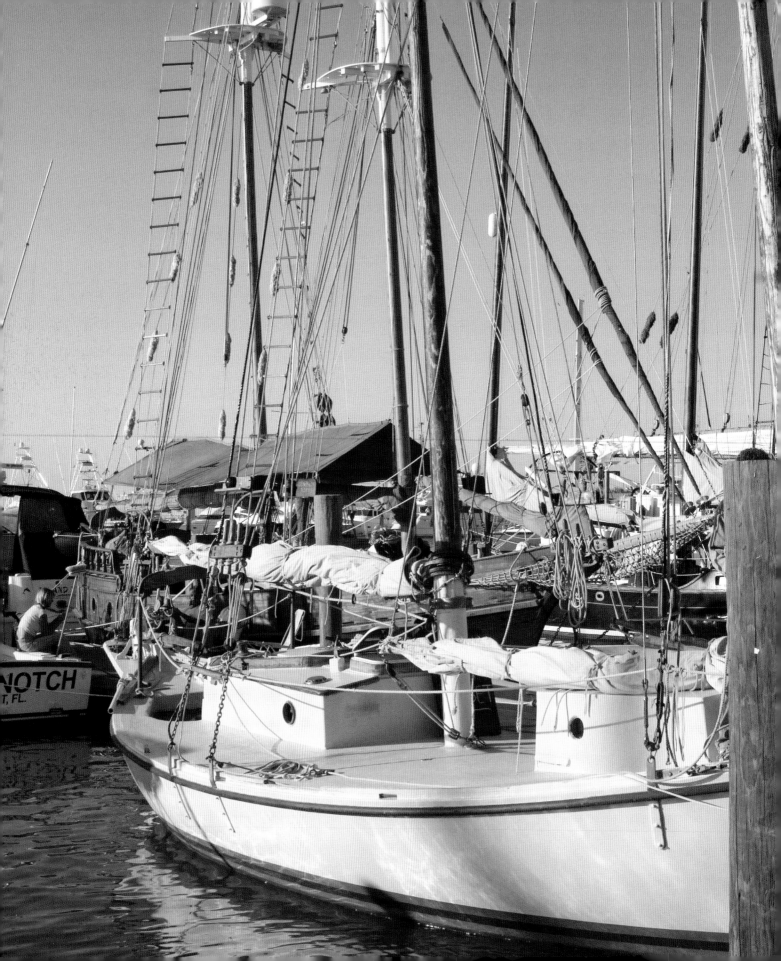

Introduction

In one of our earlier collaborations, my husband and partner, Jon Aron, and I produced a book called *Key West Houses,* which described the different architectural styles found on Florida's southernmost island. We had never been to Key West but had thought we would love the island, about which our many friends who lived there vehemently boasted, "It's not like any other place in the state of Florida."

That was in 1992, and we have been going back every year since, asking ourselves what it is that intrigues us about this little spit of land located 150 miles south of Miami and 90 miles north of Cuba. One of its draws is that it is the only subtropical city in the continental United States — meaning the weather is consistently beautiful, averaging a temperature of seventy-five to eighty degrees year-round. Another is its separation from the mainland, to which it is connected by a two-lane highway up to Miami, with water on both sides of the road. Also setting Key West apart are its size — it is only four miles long and one mile wide — and that it is mostly surrounded by a coral reef, both of which promote the small-town atmosphere that has always prevailed here.

Over the years, what used to be a funky little out-of-the-way, stuck-in-time place, has evolved into a sophisticated island resort. Each year, the island's thirty-five thousand permanent residents play host to over two million visitors from around the world, about a million of them passengers on the cruise ships that arrive daily at Mallory Square. The little Conch houses have been bought up, remodeled, and often resold. And although the gentrification of Key West is celebrated by some residents and opposed by others, the fact remains that people who have the means to go anywhere in the world keep coming back to this place, just as my husband and I have returned again and again. During our visits, Key West has grown on us: it just feels good to be here.

Boating is a big part of the Key West attraction.

Last year we decided to do another book about Key West. This time, it is a look at the new Key West—the styles of its houses and the lifestyles of its people—in order to discover how Key West has changed in the intervening fifteen years. In this book, we also hope to answer the question, What is so special about Key West?

A History of Florida's Southernmost Island

Key West boasts a colorful history. In 1815 King Ferdinand VII of Spain gave the island to infantryman Juan Pablo Salas as a reward for unspecified military services. In 1822, while living in Havana, Cuba, Salas sold the property for two thousand dollars to American financier John Simonton, whom he had met in a bar. A savvy businessman, Simonton immediately sold off portions of the island to fellow businessmen John Fleming, John Whitehead, and Pardon Green, who ultimately became prominent citizens of Key West. Streets in the section of the island known as Old Town bear their names.

Key West's location was ideal for an international port. Despite the coral reefs, ships could travel easily through the four channels that lead to its natural harbor. Simonton was aware of the island's strategic position as well. Through influential friends in Washington, he was able to establish Key West as an American port of entry, a sure means of building an economy. Simultaneously, however, an outbreak of piracy in the area caused the loss of many lives and much cargo, threatening the island's commercial growth. Once again, Simonton turned to his government contacts for help. In 1822, when Florida was ceded to the United States, the federal government took possession of Key West. Four years later, a naval base was established on the island, chiefly for the purpose of ridding the surrounding waters of pirates. For the next 150 years, a major portion of the island was devoted to U.S. Navy operations.

In 1828 the settlement at Key West was incorporated as a city, and the first houses were built in a cluster on the island's northwestern tip. By 1831 there were eighty-one

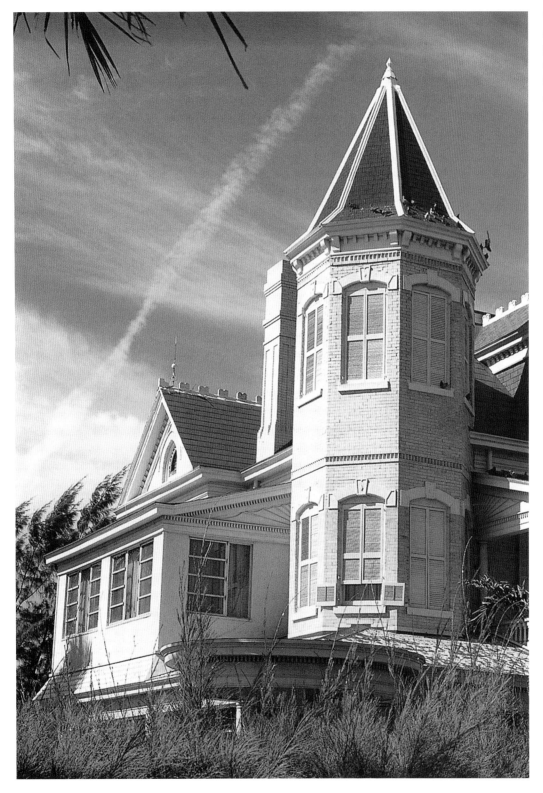

The Southernmost House was built in 1896; in 1939 it was converted into a Cuban nightclub. Today it is a thirteen-room hotel and museum. The exterior paint colors are authentic.

U.S. Route 1 starts in Maine and ends in Key West.

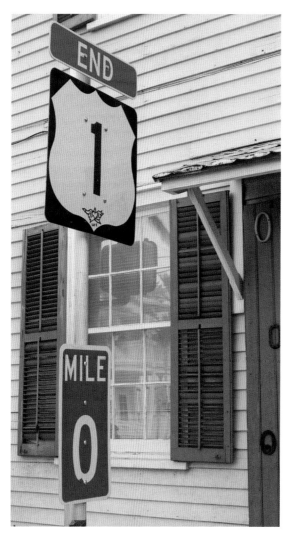

residential and commercial buildings in Key West. The population hovered at 360.

During the nineteenth century, sea traffic making its way from Havana through the treacherous reef-filled waters surrounding Key West created a wrecker's paradise. Many of the island's early settlers had been New England seafarers, and they recognized the financial possibilities in salvaging cargo. There were plenty of shipwrecks each year — enough to support a good portion of the island's population in the salvage business. Indeed, many of the grandest Key West houses were built from the wood salvaged from ships and furnished with items from the fine cargo found on board. The U.S. government eventually stepped in to organize the wrecking industry, establishing a court on the island to determine the value of the salvaged cargo. Washington also passed a law requiring that all ships wrecked in American waters be brought to the nearest American port. As a result, the wrecking business in the British colony of the Bahamas dropped considerably, and many ambitious Bahamian wreckers moved to Key West to pursue their livelihood, becoming American citizens. The industry reached its high point in 1855. As the nineteenth century progressed, however, several lighthouses were built to mark the reefs, greatly reducing the number of shipwrecks off Key West, and the wrecking business slowly died out.

Sponging and turtling had also emerged as thriving businesses. The sponging industry exhausted itself in the 1920s, but the turtling industry lasted until the 1960s, when the sea turtle was declared an endangered species and turtling was outlawed in the United States. The development of the sponging industry attracted Bahamian wreckers and fishermen who had settled in Key West, and by 1892, eight thousand of Key West's twenty-five thousand residents were of Bahamian origin.

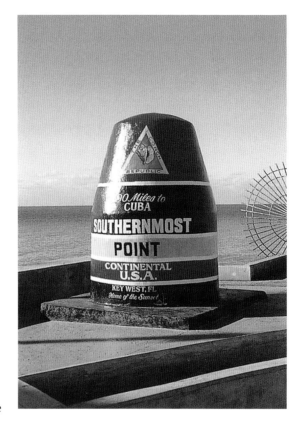

The Southernmost Point marker resembles a buoy and is near the end of U.S. 1. On top is the Conch Republic logo. It is a favorite spot for pictures.

Just three years after the end of the American Civil War, Spanish dominance over Cuba ignited a revolutionary struggle that sparked a ten-year war. Many Cubans fled their country for the nearest friendly port—Key West—and arrived bringing an industry with them, the manufacture of handmade cigars. The first cigar factory on the island had been established in 1831 on Front Street. By the late nineteenth century, the 166 cigar factories in Key West produced over 100 million cigars a year and employed thousands of workers, many of Cuban origin. The increased employment and revenues that the growth of the cigar-making business provided in the city contributed to Key West's position by the year 1880 as not only the wealthiest city per capita in the United States but the largest city in Florida.

This activity and affluence brought about an overwhelming demand for housing. Those who had come to Key West from the Bahamas, Cuba, Europe, and the eastern seaboard of the United States introduced a wide variety of building styles. This mix of

The Green Parrot bar
has been a Key West
landmark since 1890.
This one-of-a-kind,
open-air saloon
boasts the best musical
entertainment in town.

Sloppy Joe's Bar has been
around since 1937 and
was a favorite hangout
of Ernest Hemingway.

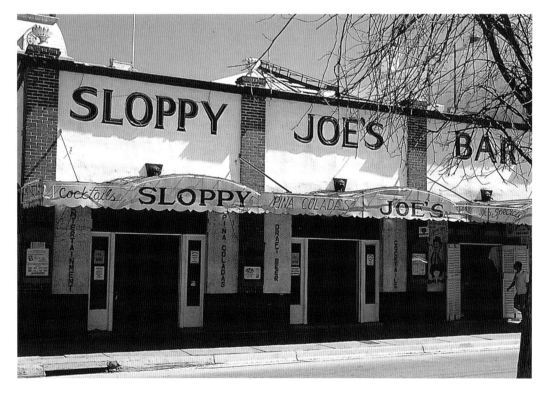

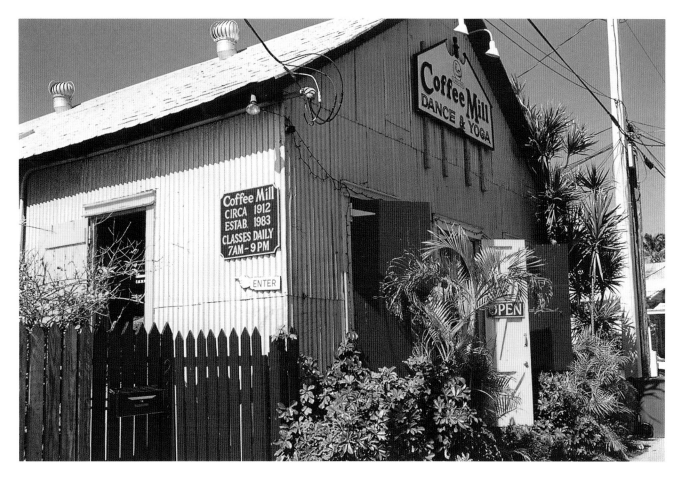

architectural styles, and the common use of wood as a building material, distinguished the buildings in Key West from those in Florida's other cities.

Although much of the lumber employed in the construction of Key West's houses was salvaged from the hulls of wrecked ships, some was found as cargo on wrecks, especially around Pensacola in the north. More affluent builders imported mahogany from Honduras, bought cypress from the Upper Keys, and purchased pine from other Gulf Coast ports. Very few interiors of the original houses included plaster, which tended to crack if a building shifted during high winds or hurricanes. Rather, even interior walls of houses were often constructed of wood. Strips of Dade County pine were typically placed horizontally to form paneled walls not unlike the interior of a boat. The island's historic district includes 3,000

The Coffee Mill building is no longer used to grind coffee. This colorful open-air structure hosts dance, exercise and yoga classes.

17

On the advice of fellow writer John Dos Passos, Ernest Hemingway moved to Key West from Havana, Cuba. His house on Whitehead Street is filled with many personal mementos and descendants of Hemingway's cats roam the grounds as a living link to the past. The house was deeded to the city of Key West and is open to the public.

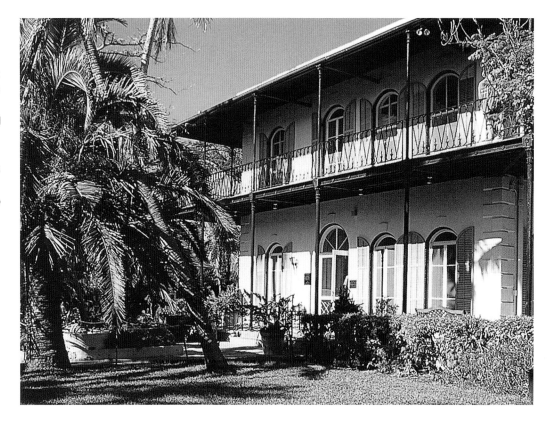

Tennessee Williams, another Key West literary figure, had his nickname "Tom" carved into the gingerbread fretwork of his gazebo on Duncan Street.

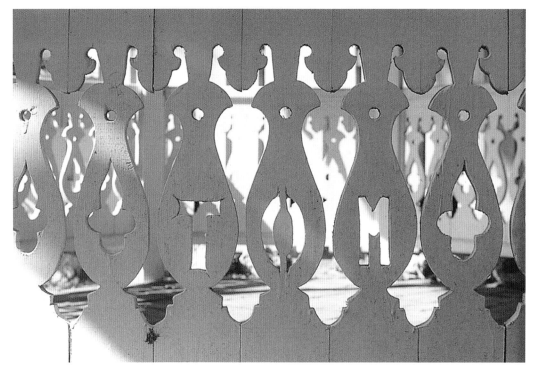

wood structures that have been listed on the National Register of Historic Places, and many of today's Key West homeowners who have renovated, even gutted, their homes, point proudly to their reuse or retaining of the original pine strips.

The word *conch* (pronounced *konk*) — a giant sea snail favored as a food by the earliest settlers from the Bahamas and commonly eaten raw or deep fried in batter to create the delicacy known locally as a conch fritter — has, over the years, come to describe anything native to Key West, including its citizens and their charming houses with wide front porches and louvered windows.

These simple wooden residences known as Conch houses reveal much about the island's past. Most of the early houses were built without the aid of a professional architect and, more often than not, were designed as construction progressed. The early builders drew on their memories of other, familiar buildings and construction methods. Those who had been ships' carpenters incorporated such practical conveniences as roof hatches for ventilation. Sea captains from New England often built sturdy, well-proportioned structures with double-hung sash windows. And widow's walks, so popular in coastal towns in New England, are seen atop the grander Key West houses along the waterfront area.

The taste for Victorian architecture that swept the country during the latter part of the nineteenth century also was incorporated into the design of many houses in Key West. Corner brackets, balustrades, porch columns, and fretwork fences, among other ornamental details, were applied to the otherwise spare Conch-style houses.

With the enormous growth of the cigar-making industry in Key West came the need for affordable housing for thousands of factory workers. Small, unpretentious, single-story houses were erected close together on lots near the factories. These simple frame houses borrowed elements from the larger homes on the island that had been built in the Victorian and Bahamian style and used similar building techniques and local materials. While humble in appearance, these small, modest houses found throughout the streets and lanes of Key

Blue Heaven is one of the most popular Caribbean-style restaurants in Key West. Located on Petronia Street in Bahama Village, this historic site once hosted cock fighting, gambling, and Friday night boxing matches refereed by Ernest Hemingway.

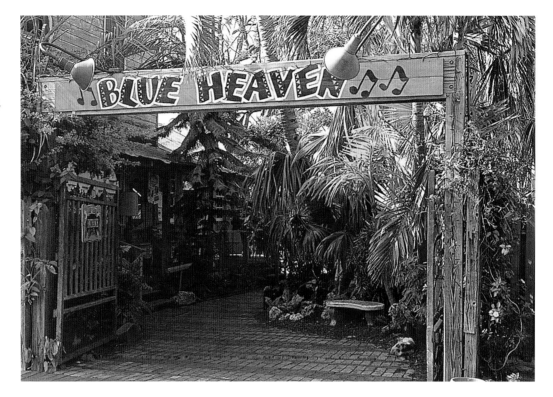

West contribute greatly to the charm and intimate atmosphere of the city as a whole and remain very much in demand today.

The commercial district of Key West also experienced a construction boom, slowed only by an uncontrollable fire in 1886 that swept through the entire commercial district, which, like Key West's residences, were constructed primarily of wood. Wharves, warehouses, factories, stores, and the city hall were destroyed, but business itself was hardly affected: sponging, cigar making, salvage and wrecking, fishing, and retailing operations continued to thrive, and the commercial district was quickly rebuilt.

In 1891 the naval commandant's quarters, known as the Little White House, were built on the local naval base. Built as officers' quarters, the compound was later used by visiting presidents, though only President Harry S. Truman actually stayed overnight. Having fallen in love with Key West, Truman returned ten times. It was said that he enjoyed visiting the island because he could walk through the streets undisturbed. Truman's presence

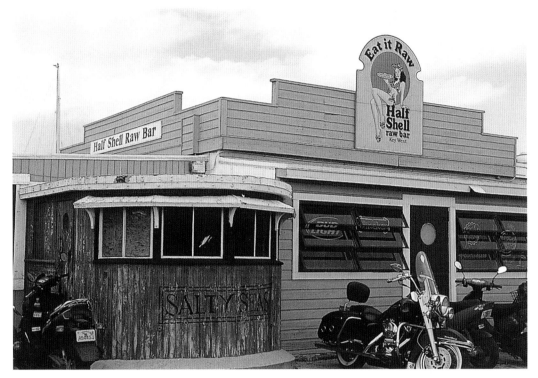

There are hundreds of restaurants in Key West, and one that has stood the test of time is the Half Shell Raw Bar along the waterfront piers. Shrimp boats deliver fresh shrimp daily.

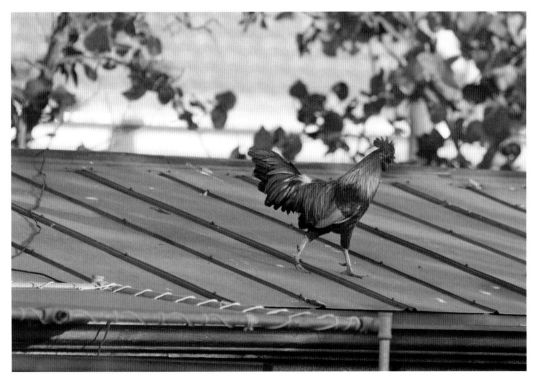

Although a chicken catcher was once employed to rid the city of the chicken over-populations, they are tenacious residents, roaming freely on the island.

President Harry S. Truman's Little White House was built in 1890 as the first officer's quarters on the naval station on the waterfront. Truman spent 175 days on the island during his term. Located in Truman Annex neighborhood, the site is open to the public.

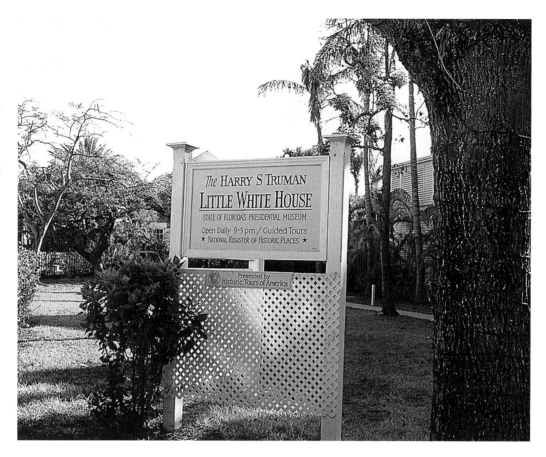

brought Key West to the attention of the public and assisted in reestablishing the island as a tourist destination. The Little White House is now a museum.

In 1904 retired oil baron Henry Flagler, well known for his development of the resort city of Palm Beach, announced plans to build a railroad from Miami to Cuba. As part of this plan, Key West would be linked by land to the rest of Florida for the first time. By 1912 Flagler's Overseas Railroad, which required the building of hundreds of oversea bridges in order to connect all the Florida Keys, reached its last American stop, Key West. Its construction cost over fifty million dollars and 700 lives. Flagler died a year after the completion of the American portion, and the railroad connection to Cuba was never to be realized. With this connection to the mainland, the population of Key West grew to thirty-five thousand, approximately the year-round population today.

In the 1920s, as the sponging industry was declining, fun-loving tourists discovered the island. But the Great Depression of the 1930s brought the high times to an end and businesses slumped. Tourists stopped coming and cigar makers moved their businesses to Tampa, seeking better transportation and distribution, as well as cheaper labor. A major hurricane in 1935 destroyed so much of the railroad that, for three years, the island was once again cut off from the mainland. Federal funds were used to convert the railroad bridges to a two-lane highway, and the automobile and truck connection did much to revive Key West's economy, making the island accessible to postwar American tourists.

La Te Da Hotel, with its restaurant and nightclub, has been an internationally famous destination for travelers for over thirty years. This landmark building was once the home of Cuban revolutionary José Martí.

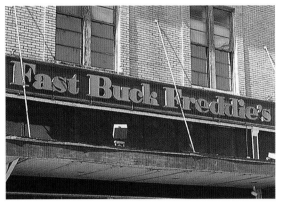

Fast Buck Freddie's, in the old S. H. Kress building, is a tropical department store on the corner of Duval and Fleming Streets. It is one of the funkiest, most diverse establishments in town. The name comes from *Red Octopus*, the first gold record by the group Jefferson Starship.

In the late 1940s, the jumbo Gulf shrimp, known locally as pink gold, was discovered, and the industry has survived to this day. Sportfishing, too—for barracuda, sailfish, marlin, yellowfin and blackfin tuna, dolphin, bonefish, grouper, snapper, and mackerel—became one of Key West's greatest attractions.

Writers and artists have always been lured by the "end of the line," and this tip of America, rich with natural beauty and romance, is still a writer's town: eight Pulitzer Prize–winning writers reside on the island. It is even rumored that there are more writers than bars in town.

Over time, Key West has suffered from many natural and human disasters —hurricanes, fires, its loss of the cigar business and other key industries—that have

This landmark drop-off laundry is cleverly named for its location at the intersection of Truman and Margaret Streets.

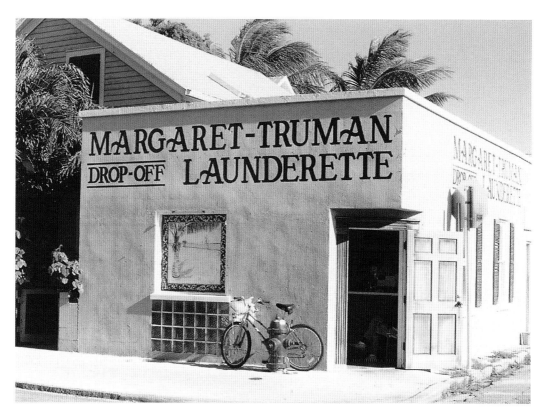

This landmark drop-off laundry is cleverly named for its location at the intersection of Truman and Margaret Streets.

created many economic ups and downs. But these fluctuations and the island's remote location have been its best protection against modern building development found in many other areas of Florida that might have destroyed its architectural character.

After 1974, when the navy closed its base in Key West, the city focused its attention on the tourist trade. This, in turn, led toward the movement for restoration and improvement of both public and private buildings. And, while Key West has long been home to a gay community appreciative of the city's unique and open atmosphere, the mid–1970s brought an increase in businesses owned by members of the gay community. Boutiques, guesthouses, hotels, bars, restaurants, and organized gay cruises have all contributed to the island's economy. Additionally, at the end of the 1970s, nearly seventy percent of all restoration and renovation was accomplished by the gay population. Their presence has contributed to the relaxed and tolerant attitude that is enjoyed by all who visit or live here.

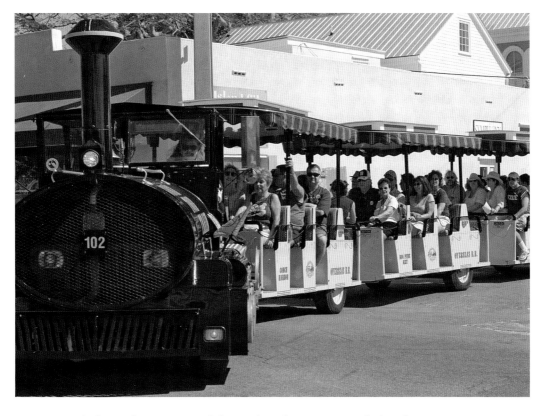

An enlightened awareness of the city's richest treasures led to the registration in 1982 of Key West as a National Historic District, which helped with the preservation of Old Town. Guidelines for preservation are made available by the Historic Architectural Review Commission, and the Historic Florida Keys Foundation and the annual Old Island Days House and Garden Tours help promote an appreciation of Key West architecture.

Key West Today

Key West is once again undergoing changes that some consider negative. Tourism and real estate are booming. This is both the good news and the bad news. Affordable housing is a problem. Automobile traffic overloads an island where the preferred mode of transportation has always been foot power or bicycle. Key West's history reveals, however, that the city has always reinvented itself with the shifting winds, and islanders recognize that growth

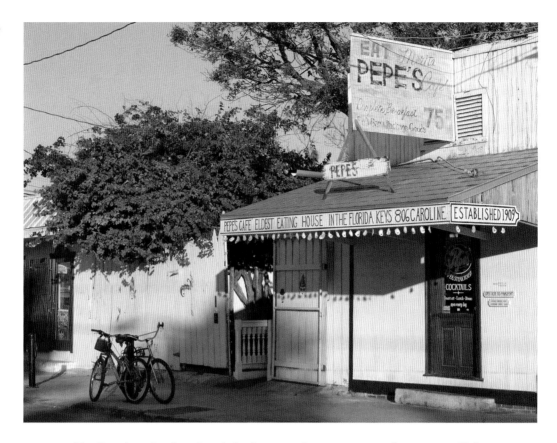

Pepe's, a waterfront café housed in a vernacular storefront, is popular with Key West locals and visitors.

is inevitable. But the island is already built up, and any remaining lots are small, limiting further expansion and almost guaranteeing that the more charming aspects of the island will remain intact.

The question—What makes Key West such a special place?—has yielded many versions of the answer: it is the people. Key West has always stood for individuality in all things. In a word, it is accepting. Who you are, where you come from, or what you did or did not do in another life somewhere else does not matter. If you are here, you are accepted. It is a cultured community with an offbeat attitude in which people of all ages socialize with one another and people are generous with their time and money, whether in the cause of mentoring a child or the preservation of historic buildings.

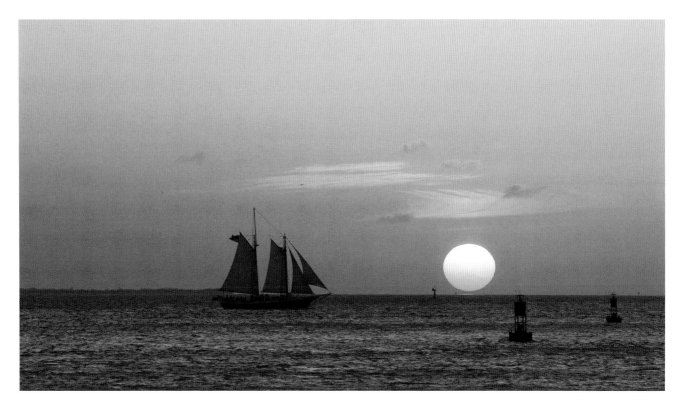

And the consistently good weather keeps the residents here and the weekenders and vacationers coming. The temperature can be as much as ten or fifteen degrees warmer than Miami, and the island's tropical breezes keep the humidity lower than elsewhere in Florida.

Key West's architecture is a charming, intriguing, mélange of styles. The houses featured in this book were selected because collectively they say something about the changes taking place in Key West, and they illustrate the creative and sensitive way people have designed their homes to suit this particular lifestyle. Together they offer inspired ideas for renovation and interior design, as well as capturing an attitude for living.

Like these houses, Key West is exciting, sophisticated, eccentric, and eclectic. Key West is always changing, but its residents are doing their best to keep the pace slow and the community spirit alive.

Sunset over the harbor renews the timeless peace of the island.

OLD TOWN

The Old Town section of Key West, a collection of more than 3,000 historic structures, was registered as a National Historic District in 1982. These modest wood-frame houses impart an unexpected charm that evokes a timeless island past.

Throughout Old Town one sees, in striking juxtaposition, elaborate Queen Anne–style houses built at the end of the nineteenth century, little Louisiana Creole cottages, ornate Victorians, and Key West Tropical houses, to which an unmistakable combination of decorative motifs is applied. Every street, boulevard, and lane is rich with architectural variations and contradictions.

Stately on Fleming

A house with a history, a good story, or a famous, even slightly illustrious, owner becomes a curiosity in any town, but especially in Key West. The stately two-story house at the corner of Fleming and Elizabeth Streets is one of these. It sits directly across from the Monroe County Library and is one of two "sister" houses built side by side by L.E. Pierce for his daughters in 1873. Almost everyone who lives in Key West knows the house, and tourists photograph it daily. The year it was built the population of the island hovered at just under thirteen thousand. Fleming Street was named for John Fleeming (later Fleming), one of the original owners of Key West. His mother-in-law, Elizabeth Rodman Rotch, helped him purchase his quarter of the island. It is not known whether he named Elizabeth Street after her, but it presents a topic for speculation.

In 1985 the house was purchased and renovated, with great care and estimable craftsmanship, by composer-lyricist Jerry Herman. Solidly built, this wonderful structure, with its wraparound porches, putty-colored shutters, and unusual rooflines sits a few steps up from street level. The palm trees along the front and side of the house shield it from too much exposure. It is one of the grandes dames in the heart of Old Town and among the most elegant houses on the island. Current owner Robert Alfandre—only the third owner since the house was built—loves this house the way it is and hasn't changed it. "Not even the furnishings, except to add some personal items," he says.

The sounds of the street disappear in the casual elegance of the front hallway, with its gleaming pickled-white floorboards. The high ceilings and the architectural

The walls of the formal dining room open to reveal the wood and cement construction design and furniture. A dead tree grows through the middle of the deck where a bevy of orchids hang from the trellis fence.

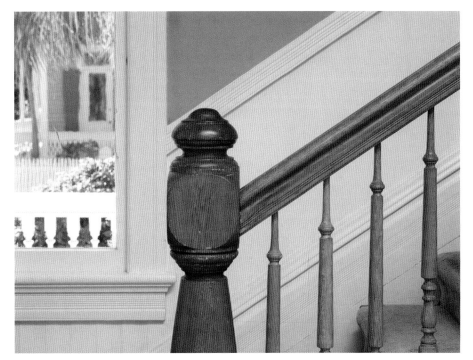

A heavy wooden newel post is one example of the architectural details found throughout this nineteenth-century home.

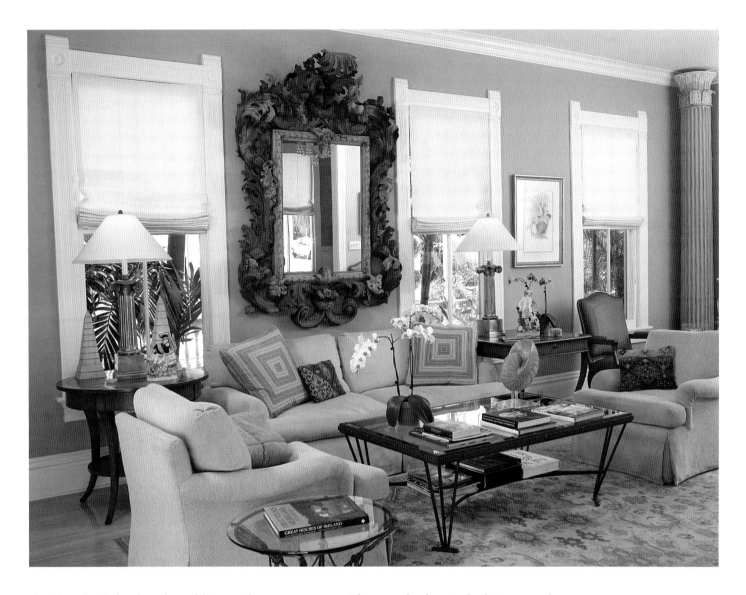

details—the Federal-style moldings, columns, and heavy wood newel post at the bottom of the staircase—are immediately evident. The hallway, with the living room to the right, leads straight to the back of the house, where there is a formal dining room to the left and a small kitchen to the right. This traditional layout is consistent with the style and era of the home.

The muted colors in the living room have a calming effect that complements the overstuffed upholstered furnishings and carefully selected accessories. An eighteenth-century gold-leaf mirror—a found object—provides a focal point for the room, as does the scrubbed pine armoire on the opposite wall. Paintings, art books, massive shells, orchids, and collectibles are

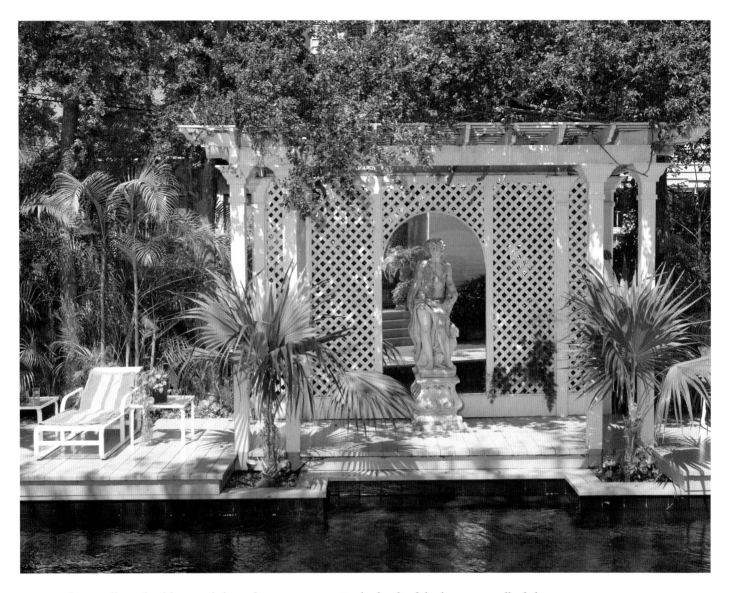

arranged on walls and tables, and the palm fronds visible through every window add lustrous color to the room. Music wafts through the residence, much as it must have when Jerry Herman was composing his famous scores for *Hello, Dolly!*, *Mame*, and other memorable musicals.

At the back of the house, a wall of glass reveals an intimate, lushly landscaped environment. "Here I am in the middle of town and I have all this," says Alfandre, who had a hand in planning the outdoor space. Tropical plantings, including colorful bougainvillea, provide unexpected privacy around a black lap pool. An arbor

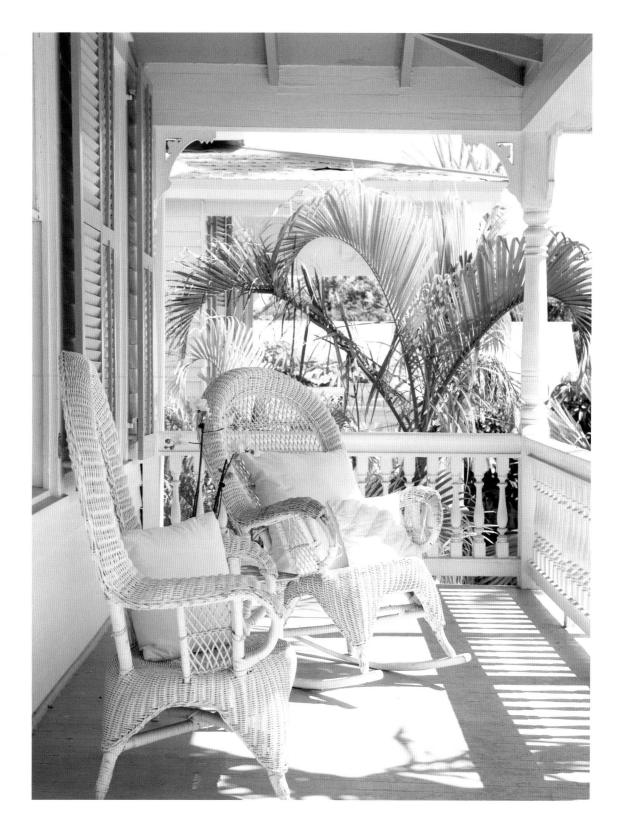

and lattice wall create an interesting barrier between properties, and a dramatic mirrored backdrop reflects the palm trees on the opposite side. The marble statue that overlooks the pool lends an air of old-world charm to this parklike setting.

Alfandre's house features a second-floor veranda, a Bahamian convention that has been adapted to the Florida Keys. These areas were often used as temporary sleeping quarters to catch island breezes during the hot summer months. The master bedroom opens onto the upstairs porch, suggesting that its occupant is sleeping in the treetops. Lemon yellow punctuates the bedroom, bathroom, and wicker furniture with just enough zest to set off the sun-dappled palm leaves. "I feel at home here instantly," Alfandre says. "I can walk everywhere." He adds, "The people here are so intelligent and interesting."

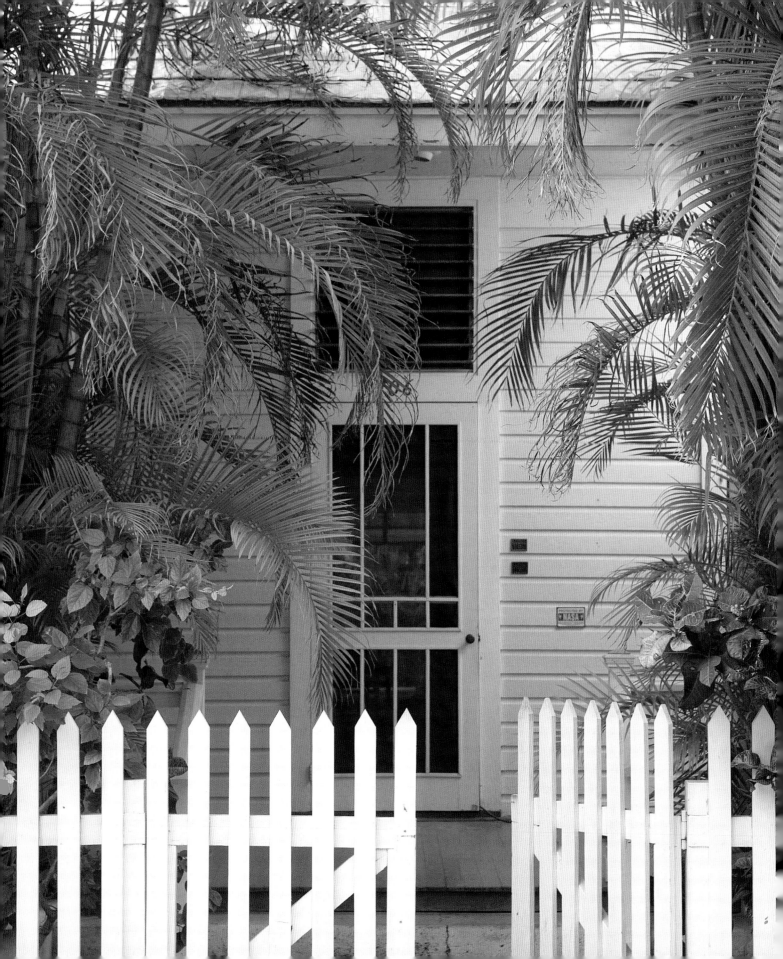

Ashe Street sits right at the edge of Old Town. Like most of the streets in Key West, it is named for an early settler, Thomas J. Ashe, one of the island's first city engineers. This area of the island is typified by two-story, wood-frame Conch houses. It is one such house that artist Lynn Sherman and her husband, Leonard Reiss, bought several years ago.

Partially hidden by the ubiquitous palm trees and a sweet little picket fence, the entryway is set back from the sidewalk. This small separation between the house and the public thoroughfare is unusual in this part of town. Inside is a long, narrow front hallway with a distinctive high ceiling. Two guest bedrooms at the front of the house face each other across the passage. Behind one of the bedrooms is Sherman's office, with a stairway leading to the master bedroom suite. Traditional in feeling, all of these areas are in the original part of the house. But it is a new space that transforms the residence into something unexpected: a living room addition as wide as the house itself.

"The addition sold us on the house," points out Sherman. "This is where everyone gathers." The room is all white, warmed with wood accents and brown sisal carpeting and alive with accessories, art, and orchids. It is a place to settle in. The new construction is designed to make the indoors flow seamlessly into the outdoors. Glass doors on all sides open to the exterior, and the sunlit lap pool is just steps away. The surrounding vegetation filters the brilliant sunlight that positively illuminates the interior.

The house is reflective of Sherman's personality. The artist studied at the Philadelphia College of Art and at the Barnes Foundation in Pennsylvania. She spends several hours each day painting in a small studio in the back corner of the property, and her work is exhibited in galleries in Philadelphia and New Jersey and at the Lucky Street Gallery in Key West (actually located on upper Duval Street). She apprenticed with

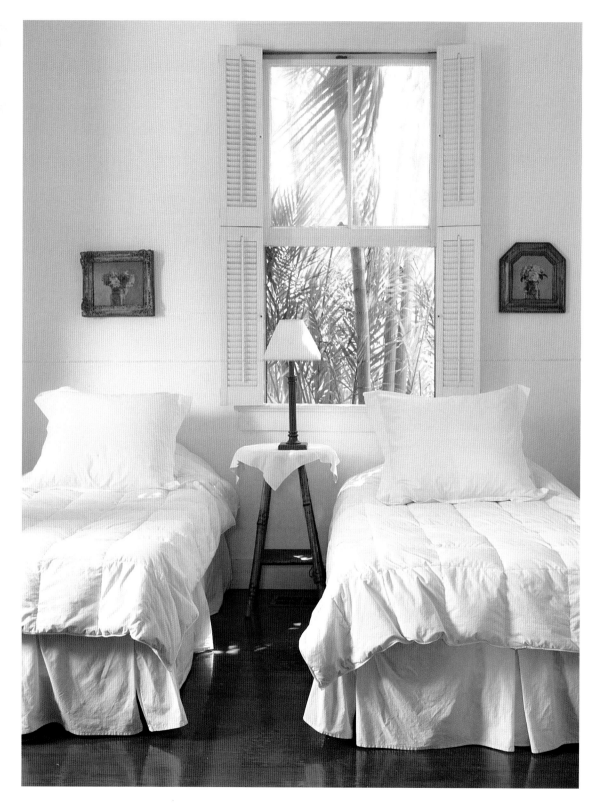

The text in the top left is too faded to read clearly.

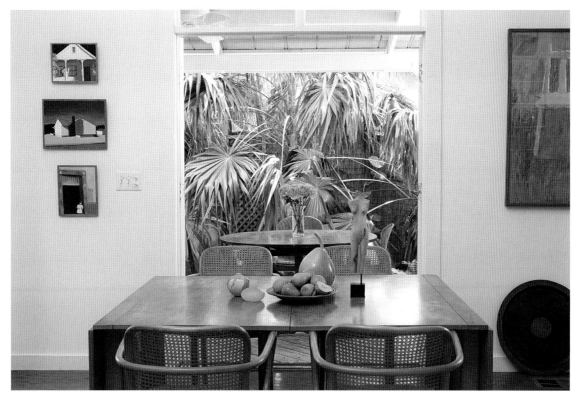

Robert Kulicke, a well-known American artist and educator specializing in still lifes, and two of his paintings hang in the guest bedroom. Sherman's works grace the walls of many Key West houses, as well as those of the Tranquility Bay Resort in Marathon, where there is a cohesive collection. "It is really exciting to see them all together," she comments.

Key West is a community of many artists, and during the winter season the art scene is ongoing. Sherman is a regular at local gallery openings and strong supporter of the other artists on the island. "The art scene here is very diversified and exciting," Sherman notes. Another of her talents is interior design. "I especially love to create tablescapes," she says of the interesting arrangements of objects, including Gae Aulenti lamps that look like palm trees. As an artist and designer, she has an eye for what works, and the eclectic collection of art and sculpture gives the interior spaces character, adding excitement and interest without taking away from the casual living so treasured in Key West. "We have fun here," Lynn says. "And that's what Key West is all about."

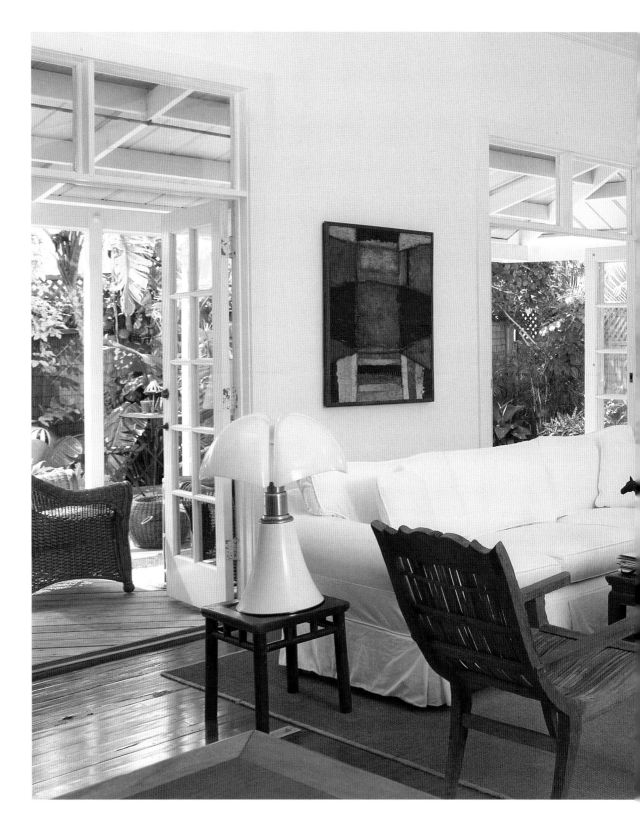

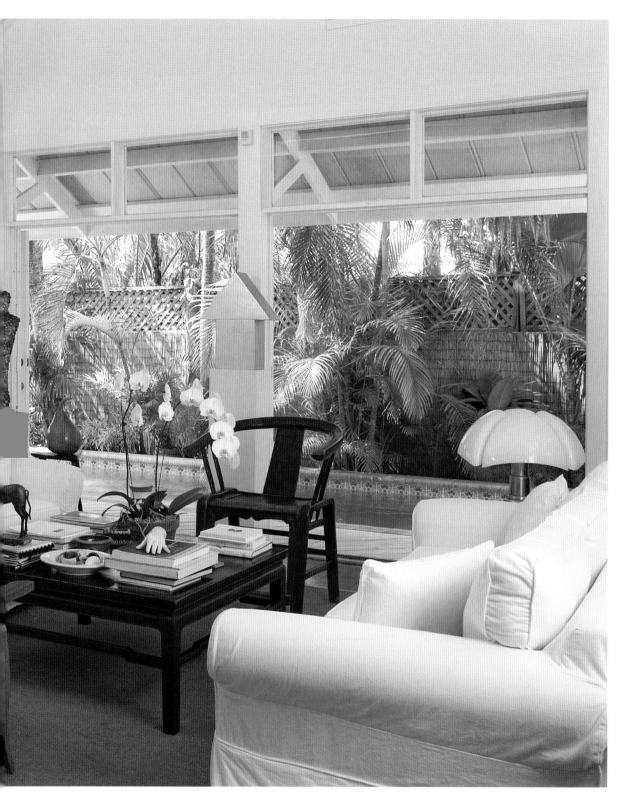

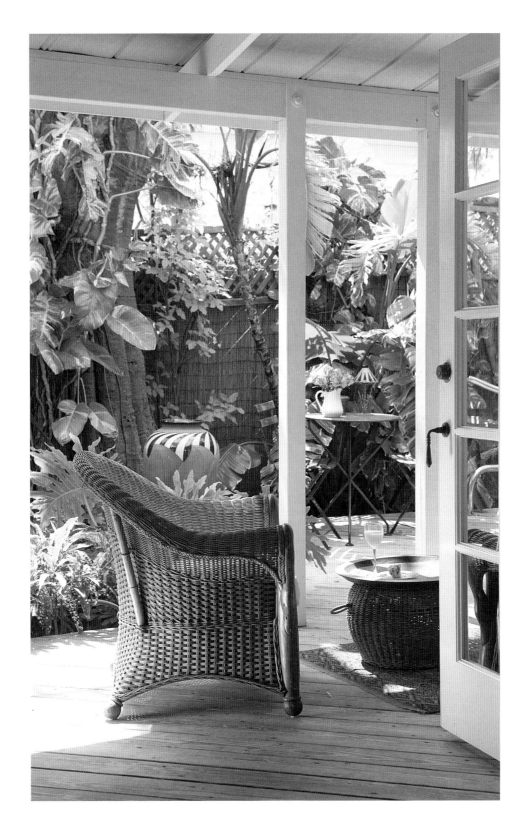

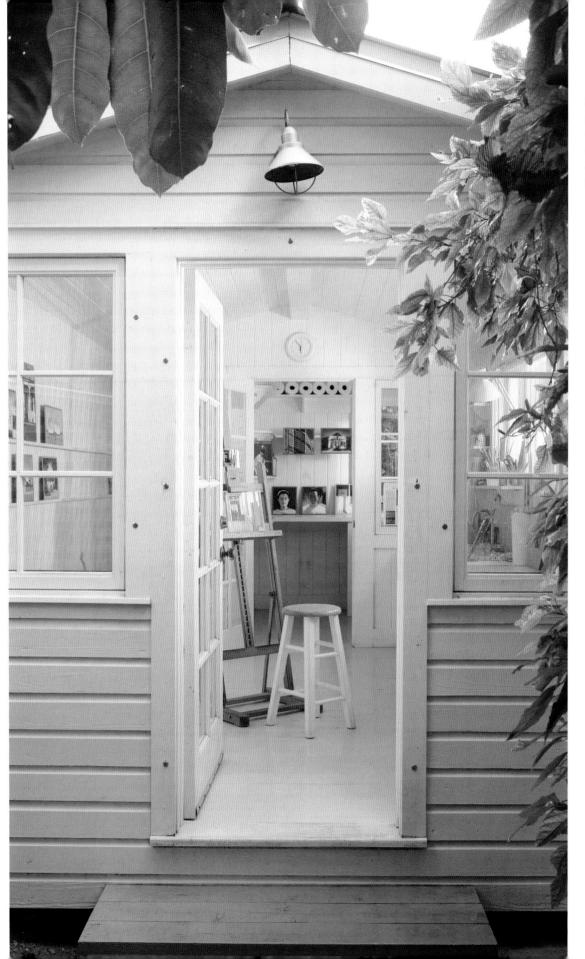

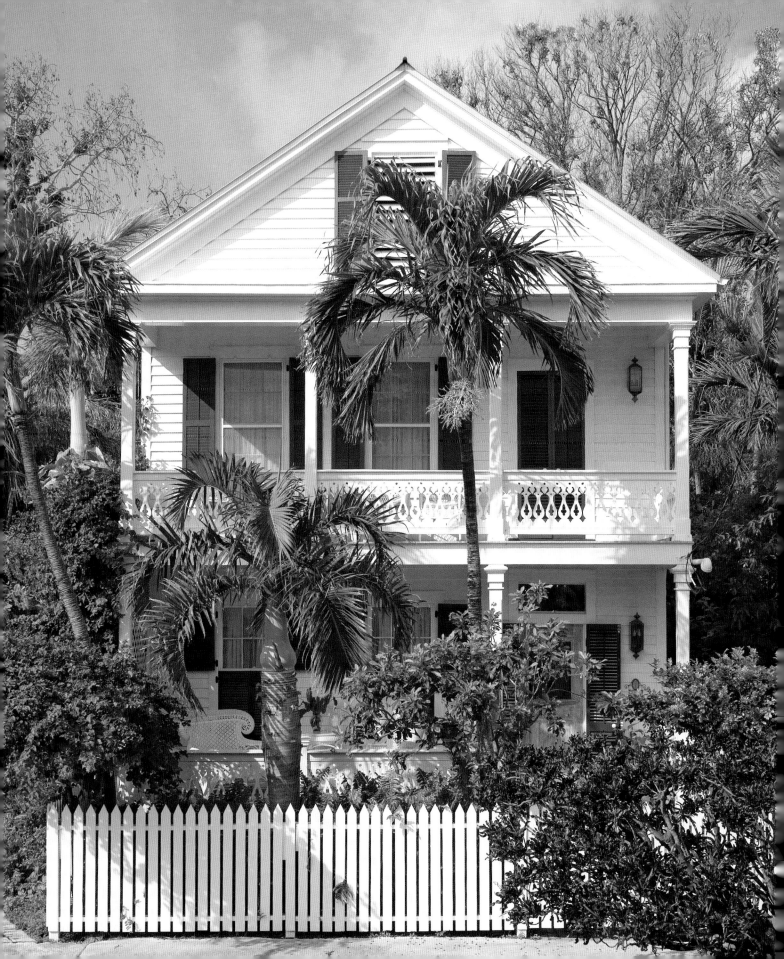

Classic Revival

When Tom and Jane Vetter bought the house on Frances Street, they had no idea how important Key West would become to them. It was through Jane's sister, sculptor Helen Harrison, who with her husband, Ben, owns Key West's Harrison Gallery, that the Vetters were first introduced to the island. "We never thought we'd live here," Tom says, "but like everyone who comes for a visit, we casually went looking at real estate, more out of curiosity than intent. When we saw this little shack, built in 1941, looking like it was on the wrong side of the tracks. . ." He shrugs as if to say, "How could we not buy it?" The story is a familiar one: this is how many Key West residents stumbled into their homes.

Frances Street, which skirts the town cemetery, is home to some of the most interesting and diverse residences in Old Town. The Vetters themselves live in a two-story, three-bay Classical Revival house with well-defined, pedimented windows and doors, and porch columns topped with simple capitals. The steep pitch of their roof —uninterrupted by the dormers, cupolas, and widow's walks found on some of the island's grander houses—is a common sight in Key West and a design originally intended to facilitate rainwater collection. Another special feature of the house is that it stays cool even without air-conditioning. "The breeze seems to find its way down the alley, across the nearby cemetery, and through the house," Jane explains. "The overhead fans are all we need even on the hottest summer days."

The Vetters' house had been in the same Key West family for several generations when they bought and subsequently renovated it. "A wing had been added to house soldiers in the forties, and the staircase to the upstairs was along the exterior wall.

The front parlor offers a
mix of textures. The sheer
drapery, plaster, and the
curved-cane couple with
the wainscot. Each one
evokes a different type
of marine life.

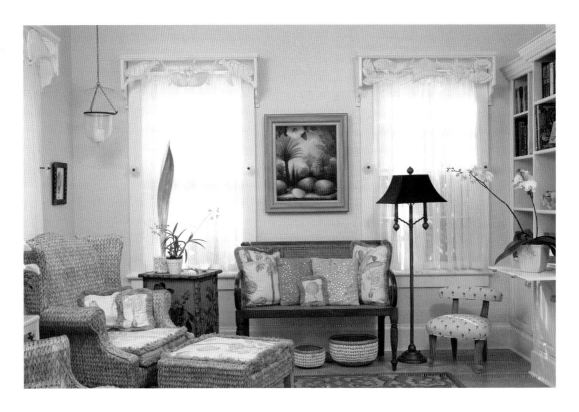

Hand-carved turtle
and fish valance.

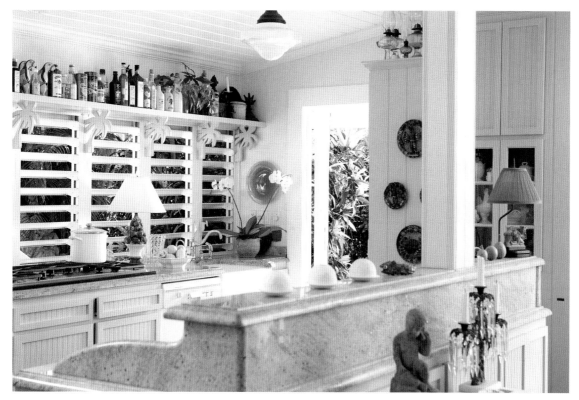

We gutted the whole thing," Jane says. It is a side-hall layout, and the typical long hallway is paneled in Dade County pine, now painted white. A stairway rises from the front hall to the second floor, where two bedrooms and baths open to the upstairs veranda.

The first floor accommodates a sitting room, master bedroom, and bath, as well as the living room and kitchen, which have been placed at the back of the house. This new layout is a modern touch that provides quick access to the backyard patio and pool and helps the Vetters maintain the year-round indoor-outdoor lifestyle that is a trademark of this subtropical island.

The couple entertains often and casually, and the open plan of the living room and kitchen makes socializing easy while meals are prepared for guests. "This is a working kitchen," Jane says. The Vetters' daughter Walton, who is a Cordon Bleu–trained chef, helped design this room. "She even made the palm-tree brackets to support the open shelves. We love their playfulness." The kitchen's Bahamian-style louvered windows—a carryover from the original structure—also add to the room's appeal.

Jane has decorated the house with confidence, thoughtfully orchestrating and deliberately choosing every color, every piece

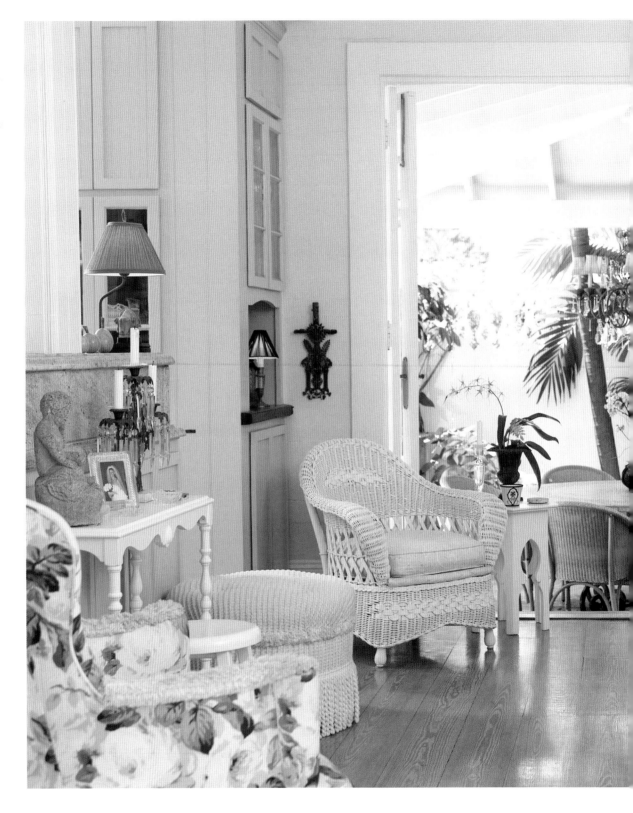

The color scheme of
[...] is [...]
green and white with
yellow accents. Globally
[...] of
antiques, wicker, and
[...]
[...] door, [...]
to the [...]

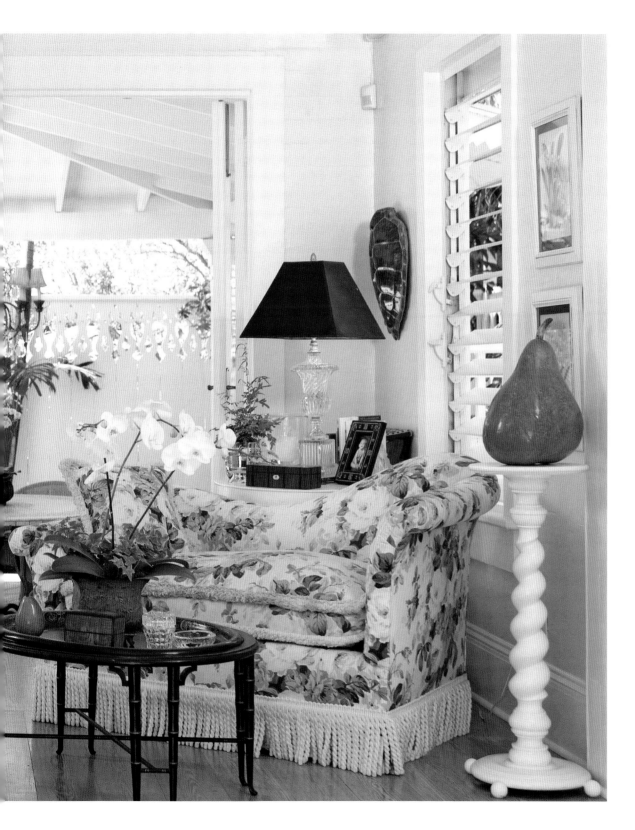

of furniture, and the art and accessories to create a cohesive whole that exudes a traditional, low-key elegance with no stuffiness or formality. Her use of green evocative of palm trees or limes, as well as white and lots of yellow, completes the house's tropical feel. More evidence of the Bahamian influence in Key West can be found in the painted porch ceilings. But instead of the preferred aqua or turquoise, Jane chose sunshine yellow, and added another pleasant

surprise in the form of a crystal chandelier. At night the lit chandelier sparkles over an elegantly set marble table, transforming porch dining into a special, magical occasion.

In the living room, wicker and painted furniture mix easily with antiques and eclectic pieces the Vetters have collected during their extensive travels. In the sitting room, a reed wing chair and ottoman sit next to a découpaged bamboo side table. A cane loveseat is piled high

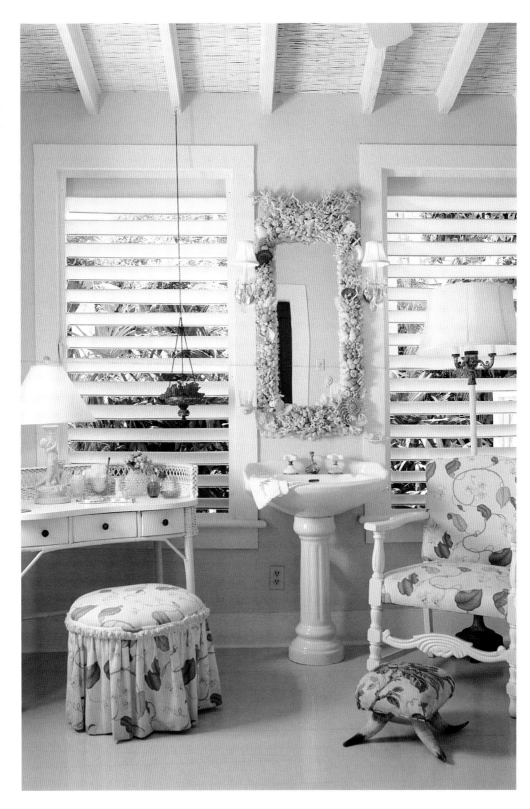

with pillows covered in subtle yellow and green palm-tree fabric. A wall of built-in cabinets and bookshelves are painted glossy white, and the sheer curtains at the windows allow light to filter into the room. Unusual valances hand carved with a variety of motifs by Lolé, a friend of the Vetters, adorn the windows.

The furnishings throughout the house can be described as feminine, but Tom does not seem out of place in the environment. He finds that an ample selection of comfortable over-stuffed chairs and outdoor verandas allows for contented reading either for business or pleasure. Jane and a partner in Missouri run a business liquidating estates, and she says she has to be careful about not acquiring too much for her own home. She confesses to a particular weakness for shells and old lamps, both of which she has used creatively throughout the house.

Combine the Vetters' enthusiasm for their house, their love of the community, and their southern hospitality, and you just cannot wait to be invited over.

A Garden of Art

Truman Annex is a section of Old Town once owned by the U.S. Navy. It is a gated community of well-maintained houses with public access to Fort Zachary Taylor beach, where artists regularly show outdoor sculpture, and to the Little White House, President Truman's vacation home. The reproduction houses of the annex were planned to complement Old Town, and one finds in these houses a mixture of all the best features of early Old Town architectural styles, whether Conch or eyebrow or Victorian. Truman Annex offers its residents a buffer against busy Whitehead Street and the beehive of downtown Key West while still allowing easy access to the best parks and beaches, shopping, night life, and restaurants, as well as the post office and other necessities of everyday life.

Pat and Phil Timyan have been island residents for more than twenty years and they spend about nine months a year here. They still return to their hometown in Michigan for three months of the year. Pat takes pottery classes at the Key West Community College, and there is evidence of her work throughout the house.

Pat and Phil have a particular interest in American folk art and outsider art, and their selective collection is showcased exquisitely. Outsider art is work created in all different media by artists who lack formal training or particular education in the arts and who often live in rural areas, isolated from current trends or influences. This art is often described as naïve and devoid of sophistication in a positive way and is appreciated for its directness and purity of artistic expression.

John Martini's *Adam and Eve* stands by the gate of Pat and Phil Timyan's house.

57

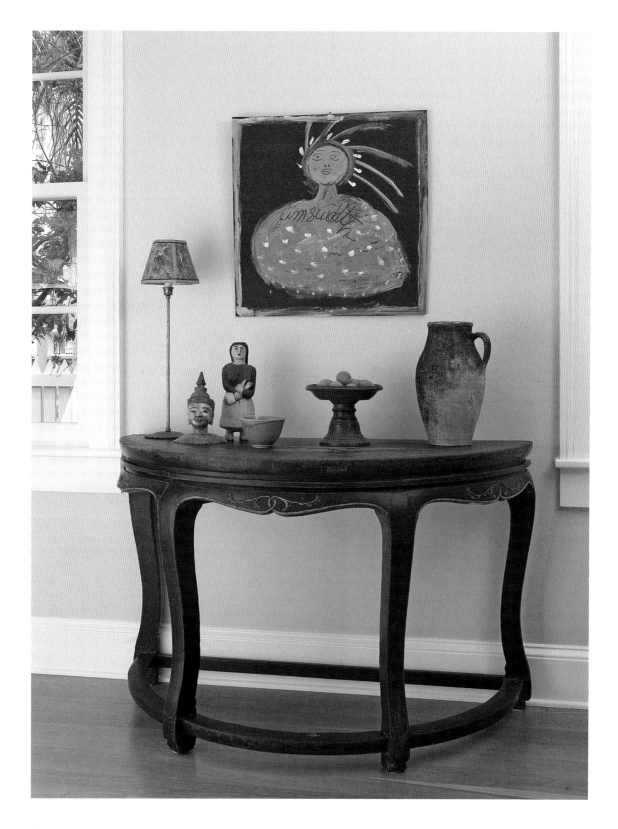

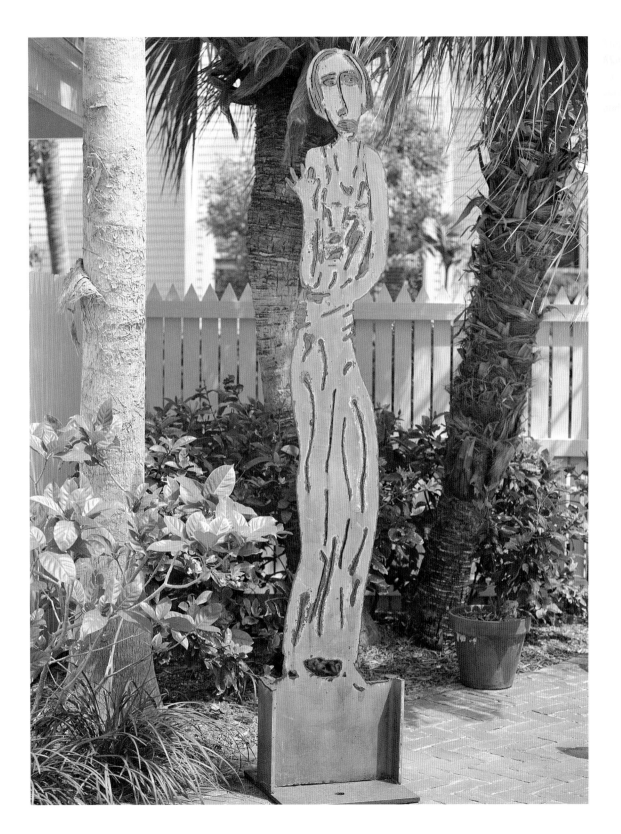

59

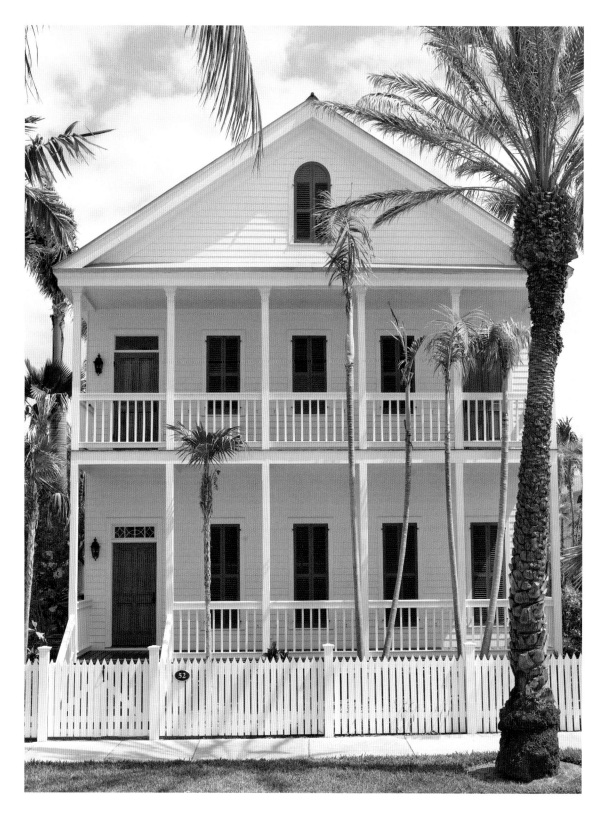

The three-story Classic is a tall house, typical of the grand residences in Truman Annex.

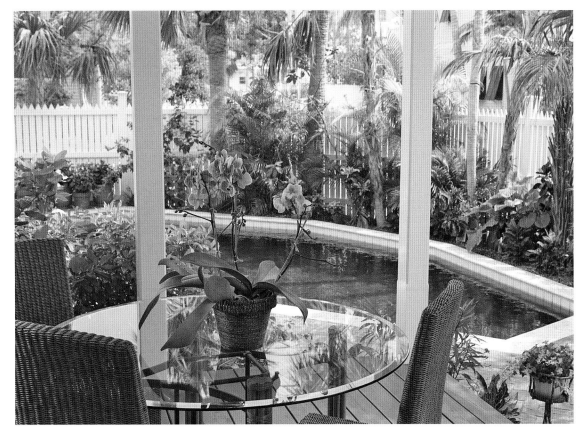

The Timyans also have a particular fondness for the metal sculptures created by artist John Martini. They bought his early pieces when he first showed his work in a Key West gallery and have continued to collect over the years. Although two of Martini's metal figures are in the house, most of the collection is integrated into the landscaping around the pool. When Pat Timyan sought landscape designer Pat Tierney's help in planning the garden, she and Phil knew the sculptures would be part of the overall design. "They aren't obvious at first," Pat says, "and that's what we like about them."

While Pat says the garden landscaping around the pool evolved, the clusters of plants and tall shrubs such as croton, flowering hibiscus, bay rum, and fragrant Florida gardenia look carefully planned. For added color, Pat places pots of flowering plants amid the greenery. And because Key West's wonderful weather makes it possible for the Timyans to leave "real" furniture on their roofed deck most of the year, they are able to enjoy comfortable outdoor living and dining with a garden view.

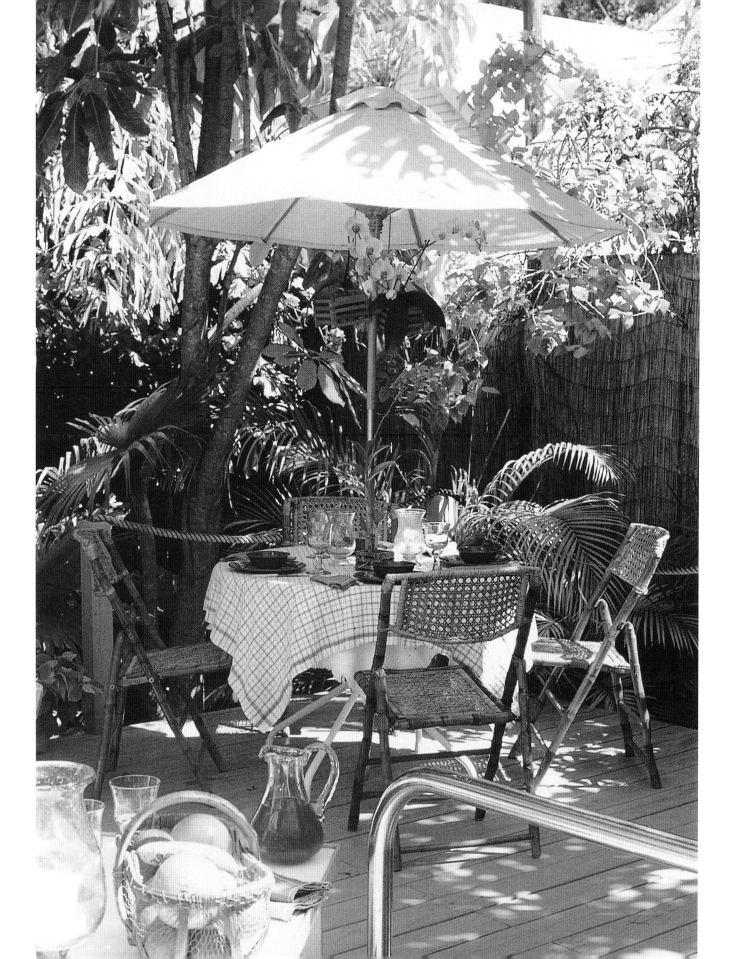

Two properties in Key West are like tiny islands within an island where the owners have created wonderful environments for their lifestyles — outdoor entertaining. Whether it's an intimate gathering of four or a poolside party for forty, both couples entertain with style.

Carol and Karl Lindquist live in a typical Conch house on Love Lane. Their house has evolved with many small additions and changes, including moving the kitchen to the back of the house by reclaiming what was once an orchid room. Carol Lindquist is the author of *The Banana Lover's Cookbook*. Both she and Karl are creative cooks who love to arrange casual poolside gatherings with visiting writers and lecturers in town for the Literary Lecture Series. "It's fun to put lively conversationalists together," Carol says.

On the opposite side of Old Town Carole and Gerald Fauth live in one of the first houses to be built in Truman Annex. The Fauths designed their house with Bahamian influences — aqua shuttered windows and wrap-around porches. Their little compound includes a guest cottage with a pool between the two houses. The covered porch is an extension of the open floor plan, with the dining, living, and family rooms all opening onto it. White wicker furniture with blue cushions continues the color scheme from indoors, and pots of pink impatiens add spots of color both here and around the pool. Louvered shutters lift out to shade the porch, and a wall of palm trees supplies privacy and a tropical feeling. The result is a wonderful place for entertaining with ease, which Carole and Gerry do often.

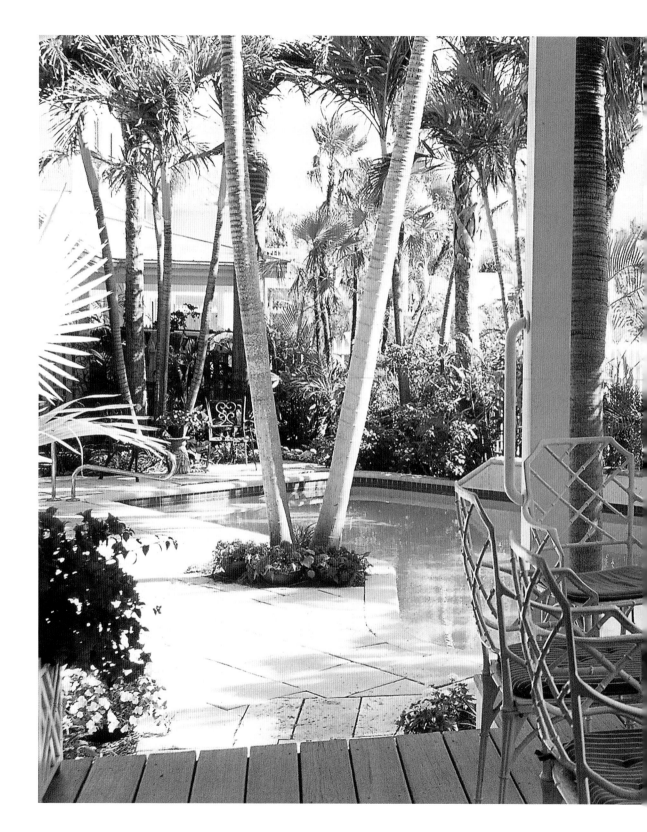

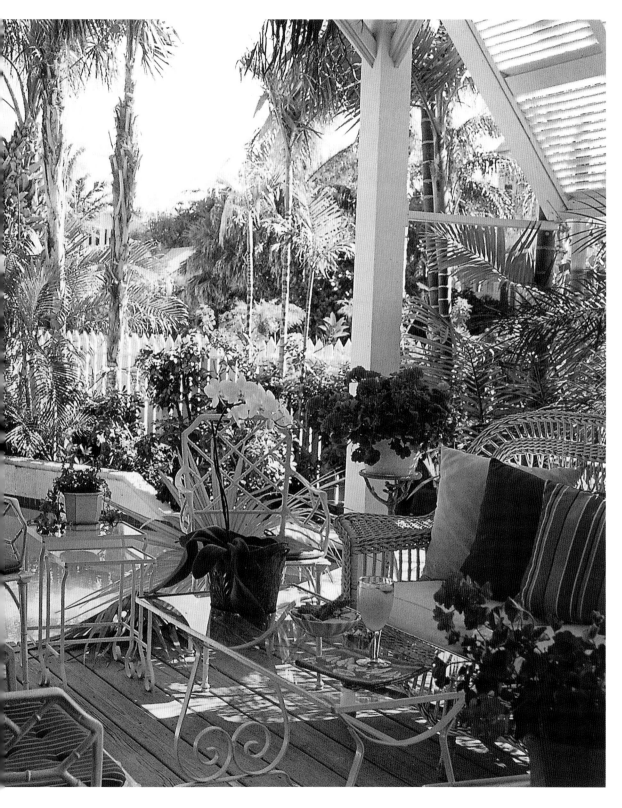

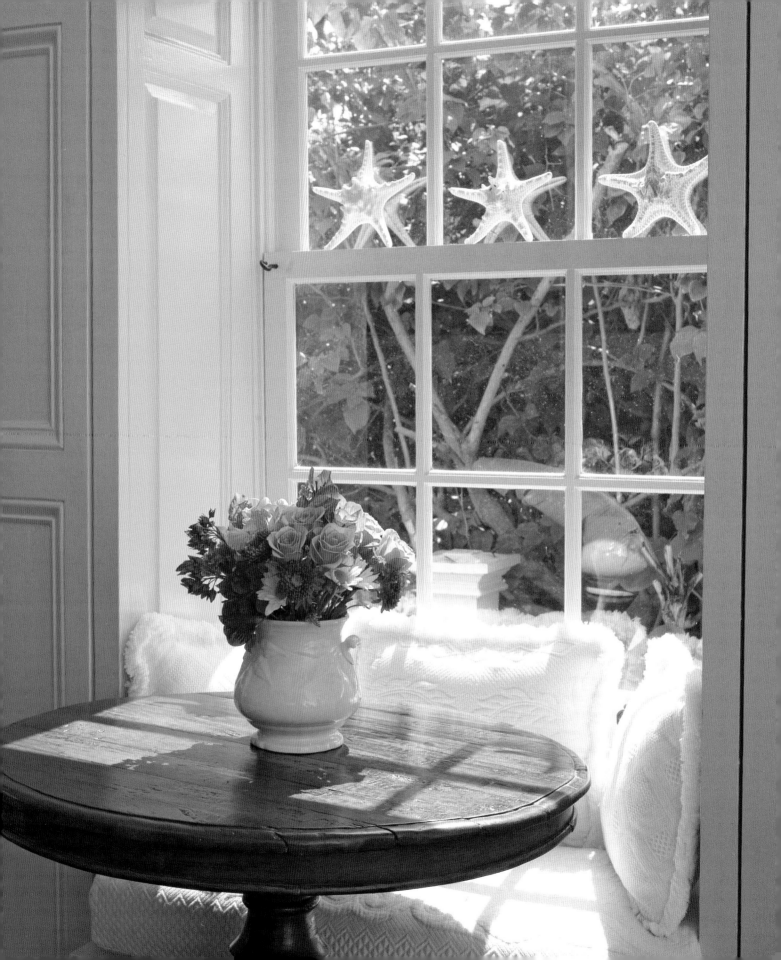

"Come over at seven tonight," Michael Pelkey suggested. As we approached the house on the corner of Southard and Grinnell, everything was aglow and we knew immediately why he wanted us to come after sundown. Hundreds of votive candles lined the railing of the front porch and the window ledges. The small cottage, even by Key West standards, made an enormous impact on this block of unassuming Conch houses. Passersby stopped to admire this little jewel, perhaps wishing they were invited to the party. But there was no party. This is just Pelkey's way of doing things.

"The house was a falling-down shack when I bought it thirteen years ago," Pelkey says. "It was built in 1906, and it was the only structure — I can't even say it was a house — that I could afford." That he was able to find a low-priced house in an inflated market is a source of pride. "I looked at forty houses over two seasons," he continues. "There were squatters in this one at the time. I really liked the shape of the house, and the location is perfect — close to everything — and the empty lot next door can't be built on. Everyone thought I was insane, not only because it was falling down, but because it was so small. The lot is only thirty by fifty feet. I figured more space would just mean my bedroom would be two feet larger. So what? This house is perfect for me, and I will never sell it for a larger one."

Pelkey knows how to make the most out of the least, and his house is tangible proof. He was able to turn this fixer-upper into a home that has been featured in dozens of magazines and a book or two. And although five hundred square feet is not much living space, Pelkey has managed to carve out a living room, kitchen, bedroom, and bath without the space seeming cramped. Every inch is used inventively. "My brother Larry is a contractor

The cottage, in Old Town
Crescent Lane, was built
in the early 1900s and
remodeled in the 1990s.

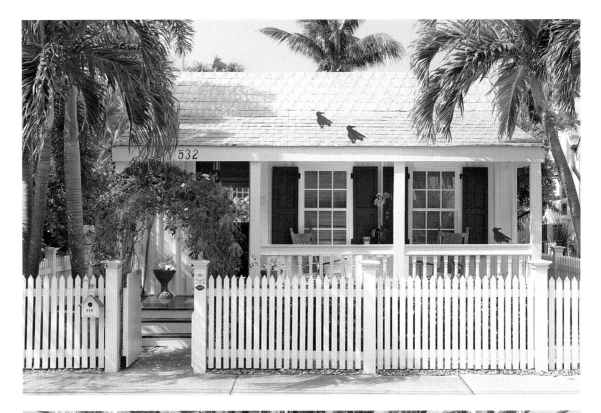

A recent ... includes an
outdoor table and seating
area for parties. Crystal
chandeliers and velvet
candelabra hang from
twin royal palm trees,
with hundreds of clear
Christmas lights. "When
I have a dinner party I
mix ... casual and ...
... porcelain. And
the mostly 19th-century
French silverware I found
in a flea market," says Polley.

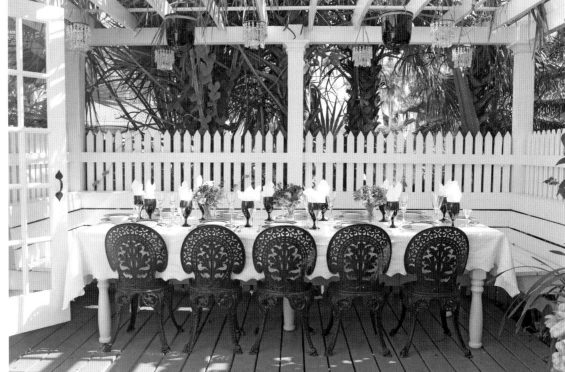

68

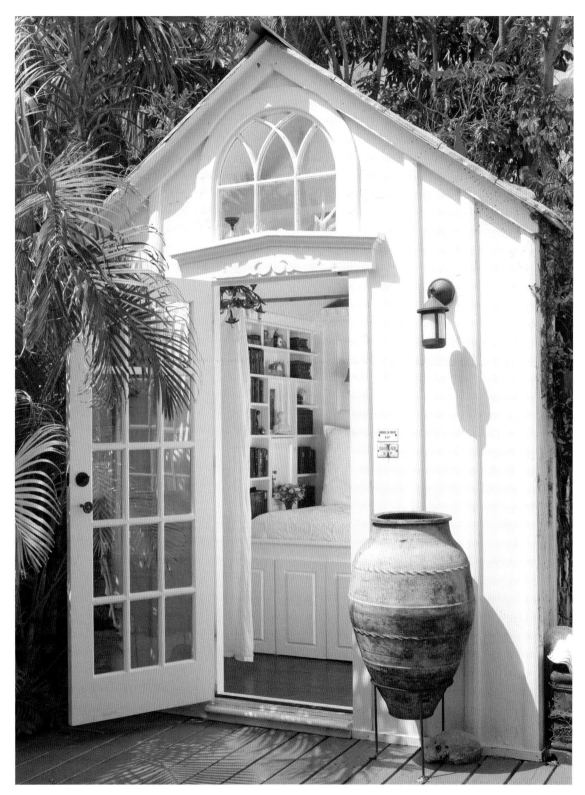

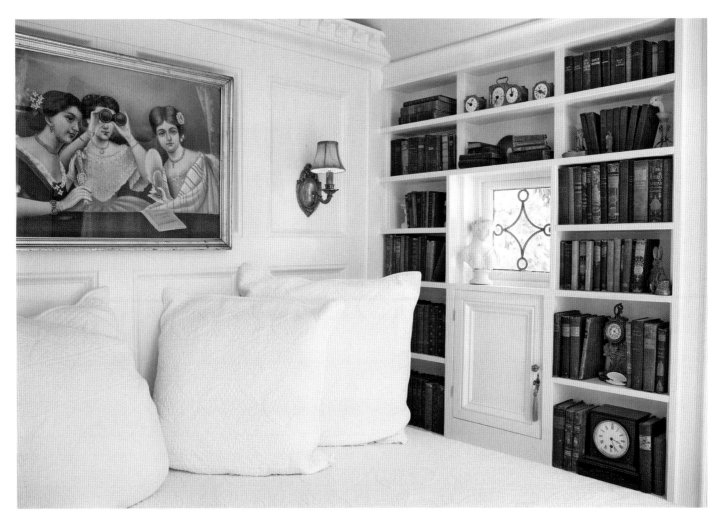

and master cabinetmaker," Pelkey says by way of explanation. "He came up with some amazing solutions for storage, as well as creative, fun things like the birdhouse mailbox, the metal sculpture of crows on the roof, and the built-in bed in the shed." The shed, it turns out, is hardly what one might normally think of as a place for storing tools and the messy stuff. Instead, it is a private aerie Pelkey uses as his bedroom, leaving room in the house for the occasional guest.

The house is divided by a center wall. An open living room and kitchen occupy one side; the bedroom and bath are on the other. The entire back of the house opens to an enclosed deck that features an amazing privacy wall of shells and a fountain that Larry and Michael Pelkey built "one shell at a time."

As a private chef for many years, Pelkey acquired an appreciation for living well. His good taste and an ability to ferret out the pearls

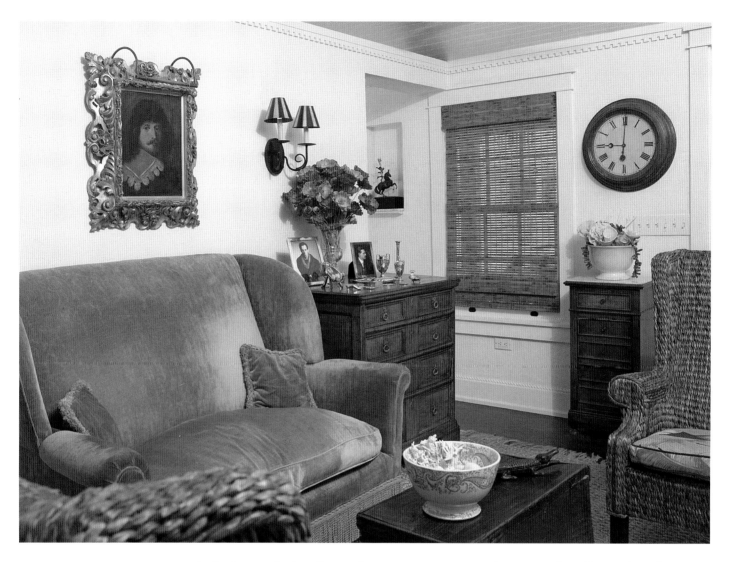

among the junk at yard sales, flea markets, trade shows, and antique junktiques have earned him a reputation in the interior design business. It was a natural progression, then, to reinventing himself as the man to call when you want your home to ooze charm, character, unexpected details, and a bit of joie de vivre. His style can be described as funk and flash with a whole lot of substance. "I look for great stuff at great prices everywhere I go and combine flea market finds with unusual antiques." Pelkey's motto might as well be More Is Definitely Better. In fact, one of anything will never do, and everything he buys has some wonderful detail that makes it interesting. He collects all sorts of hinges and knobs, another passion that distinguishes the houses he decorates.

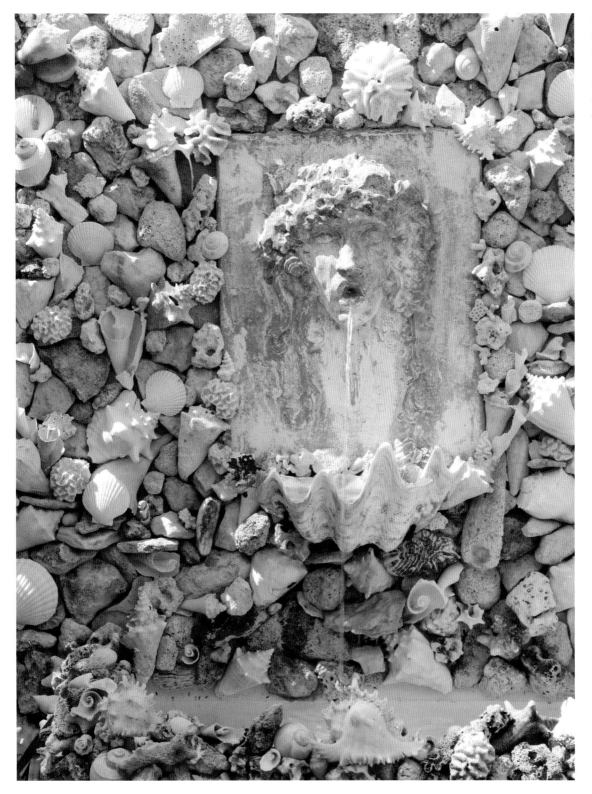

Although Pelkey's house is small, his furnishings are not miniature. Two large sea grass wing chairs and a velvet loveseat in the living room provide comfortable seating. But Michael points out a chest of drawers as being his "favorite piece." "I bought it from interior designer Alexander Baer. I called to make an offer, and he said if it was for me personally he would take my offer. I was so flattered. I hope he knows how much I enjoy owning it." The matchstick Roman shade is one of Michael's signature touches and a good window solution for most of the houses he decorates.

The living room leads into the yellow kitchen, which is as at once functional, aesthetically interesting, and very compact. But in this tiny room, Pelkey often whips up a meal for twelve or prepares for a cocktail party that might include seventy-five.

And what would Pelkey do if he had some down time? "I don't have enough time alone. But right now, I'd have a White Russian drink and go dancing. I love to dance — anywhere, anytime."

"I am home!" Betsy Smith exclaims about her Old Town apartment. "I adore my apartment. I love small-town living and especially all the lovely tropical colors here. This is not like the rest of Florida."

Unlike most cities in Florida, Key West has few high-rise condominiums lining the beaches. In the past two or three years, however, with the cost of real estate skyrocketing, private homeowners have been converting their two-story houses into condominiums or apartments. All over Old Town, there are charming apartments in older homes that provide housing for more residents.

When Smith first arrived in Key West, she opened a home-furnishings store. Hers was a shop where people went to find something unusual, whether a length of architectural molding or a 1920s rocker. This was a destination store or a place you stumbled on and kept returning to just to check on what new things might have come in. Eventually, the time and travel required to keep the store filled with interesting objects forced Smith to close shop. She settled in Savannah briefly, until she realized what she had left behind. "Living here is a dream," she said. These days, Betsy Smith is liaison between the Conch Tour Train, for which she did a short stint as a trolley driver, and the many cruise ships that regularly dock at Mallory Square, and this friendly woman could not be better suited to the work.

Smith lives on the second floor of a wooden two-story Bahamian-style house on Angela Street, named for Angela Mallory, wife of Stephen R., after whom Mallory Square is named. Typical of this architectural style, every room opens onto the wraparound porch. The original Dade County pine on the interior walls has been retained, contributing to the apartment's shiplike feel. The apartment is crammed with things she loves, much of it having come from the antiques store she ran in New Jersey for thirteen years before her

COTTON BLOSSOM

NEW ORLEANS, LA

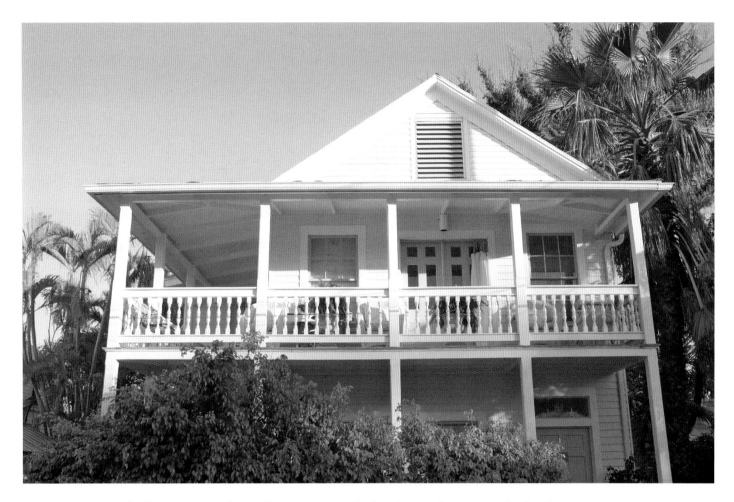

Key West venture. "I like to surround myself with favorite things from the past," she says. "Every piece has a story or history behind it."

Smith favors furniture with the sort of character that comes from worn paint, and knows how to work magic with found objects. She cleverly devised ways of delineating areas to offset her apartment's open floor plan, creating a dining alcove, for example, simply by simulating a wall with someone's discarded louvered shutters.

Like her friend, designer Michael Pelkey, Smith is never content with just one example of the things she likes. Turquoise milk glass, painted furniture, and vintage fabric punctuate the space and spice up the room, and a strategically placed yellow urn demonstrates her eye for color. Layers of carpets are placed at angles, good antique furniture is mixed with folk art, and interesting tablescapes of collectibles are arranged on every surface. The color scheme extends to the wicker furniture and accessories on

In the dining room,
a collection of white
porcelain tableware
fills a cupboard by 18th
Century, and platters
are mounted on the
warm pine wall. The
compote cake is filled
with white hydrangeas,
... by so throughly used
throughout the rest of
the apartment.

the porch. Shells are used extensively wherever possible: across a shelf above the doors and windows, in baskets on the floor, over an armoire, and in large urns on the kitchen counter. There are other sea-related objects of interest, such as the majolica dolphin pitchers in the kitchen, a swordfish and the "Cotton Blossom" lifesaver over the doorway, and, just for fun, the blue boat oars on either side of the door.

The apartment is comfortable yet stylish, elegant but timeless, and even sexy—a place good to return to after a long day. Above all, though, this is an apartment Smith is happy to call home.

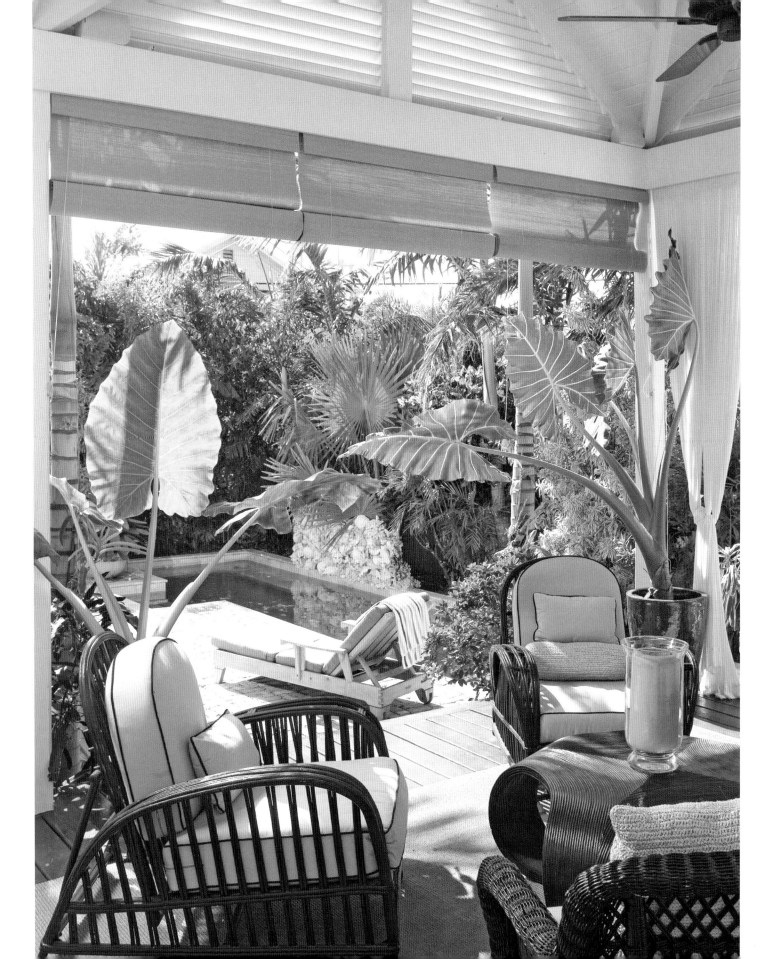

Space is a big issue in Key West. Anyone who wants more room must renovate or expand slightly, either upward or, when possible, outward by very small increments within stringent building guidelines. The island is small, the houses are small, and there is virtually no open land left to develop.

Like so many in Old Town, Claudia Miller's house started as a small, dilapidated structure. An empty lot next door, however, made possible the addition of a new side wing that could accommodate a living room and a bedroom. The second floor of the old part of the house contained a bath and two bedrooms—one of which became a small artist's studio for Miller, and the other a room for guests who are only too willing to visit during the winter months. A new kitchen was installed downstairs, and beyond it, a new porch overlooks the pool. "This is my outdoor living room, where I spend all my free time," Claudia says. "I even have a small television in a cabinet in the kitchen side of the wall."

Miller bought the house from the design firm of Gordon Alvarado and says she has not changed a thing. "I did sneak in some 'girly' things," she admits, though, pointing out a beautifully worn leather chair with a gracefully curved wooden frame. This house has an *Out of Africa* feel, and Claudia says, "When I saw it I knew it represented me in a way I never could have done on my own." This is exactly how Blair Gordon designs the interior of a house. He strives to renovate and decorate with a theme suitable to the architectural style of the house and then waits to marry it with the right buyer.

The house is set back from the street almost on the corner of Grinnell and Eaton, two busy streets in Old Town. A white picket fence surrounds the property, and the front is paved with worn bricks. Miller parks her bike here and uses it daily. The massive front door, with its heavy brass doorknocker, muffles the sounds of everyday life outside. Right inside is a hallway lined with Dade County pine stripped down to reveal its warm brown

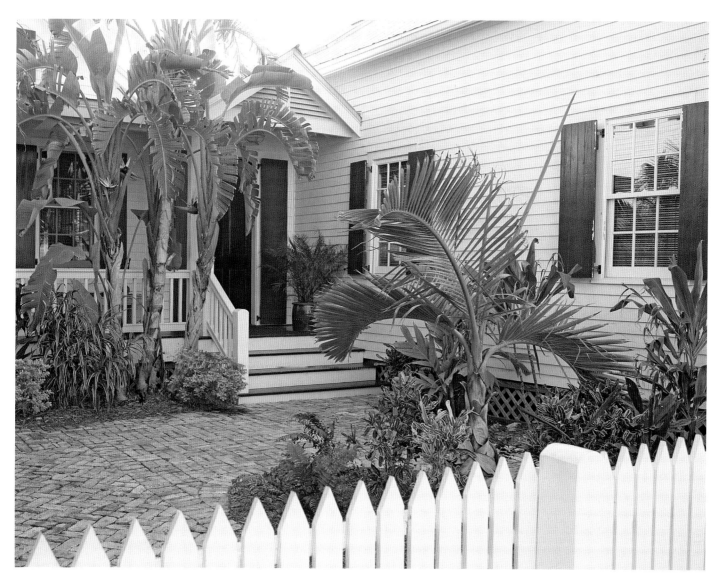

color. "This is the only part of the old structure that has been preserved. They salvaged the best boards for the living room," Miller explains.

Claudia Miller spends the winter months in Key West, part of the rest of the year in her renovated loft in New York City, and the summer in Martha's Vineyard, where she is the director of Artists Pointing the Way, a visiting artists program. An artist herself, she uses her time in Key West to create collages of found metal pieces. "I pick things up on the beach or when I'm walking my dogs," she explains. "Whatever appeals to me is incorporated into my work. Sometimes I work upstairs in the little bedroom

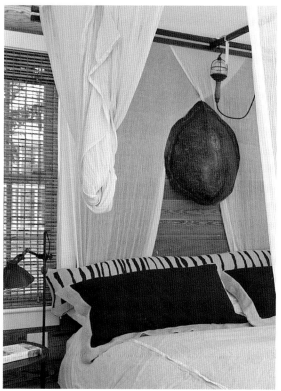

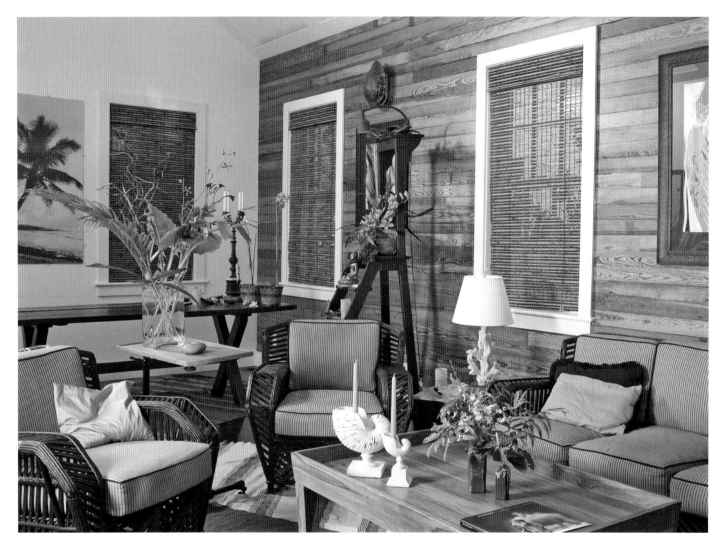

studio, but lately I've had a table set up on the porch outside of my bedroom where I've been painting funny little odd-shaped pieces of coral."

The house has a multicultural African theme, and Miller says it feeds her spirit. "At the root of every culture," she says, "you have the mystical and spiritual, and the sensitive renovation and decoration of this house responds to that inner search I have for a sense of place and well-being."

Side by Side

Perfecting their house and garden is what makes George Korn and Richard Kemble tick. Their house is located on Eliza Street, in the Old Town historic district. It had actually been two side-by-side Conch cottages, but a living room was added to connect them. "I don't think we'll ever sell this house," says Korn.

The house is set back from the street, behind a weathered fence. One enters through the gate, walks up a brick path, and steps onto a covered porch that gets the early morning sun, making it an ideal breakfast spot. Inside, this double house has plenty of room for a master bedroom suite on one side of the living room and a guest bedroom and bath on the other. A winding stairway leads to a loft area that George uses as an office. And since Kemble is an artist, one side of the house is his studio.

"We really didn't have to do much to the house when we bought it," Korn says, but Kemble goes on to explain that they "replaced two of the bedroom windows with doors leading to a narrow deck where we put an outdoor shower and more plants." Kemble continues, "That little change opened the house up just a bit more." An expanse of glass doors, which fold over each other accordion-style, opens up the entire back wall of the house and creates a seamless transition from inside to out. This has the effect of doubling the living space.

And of course the goal in Key West is to live outdoors, and Korn and Kemble had the deck and pool redesigned to better suit their needs. "Guillermo Orozco designed the black pool and fountain," Kemble says. "We found the Buddha head and the cylinders and added some white coral pebbles from the beach. The trickling fountain is a peaceful sound, and the whole thing has such a Zen-like feeling."

Korn and Kemble replaced bedroom windows with doors that open onto a narrow deck. Orchids, flowering plants, and objects of art fill the area.

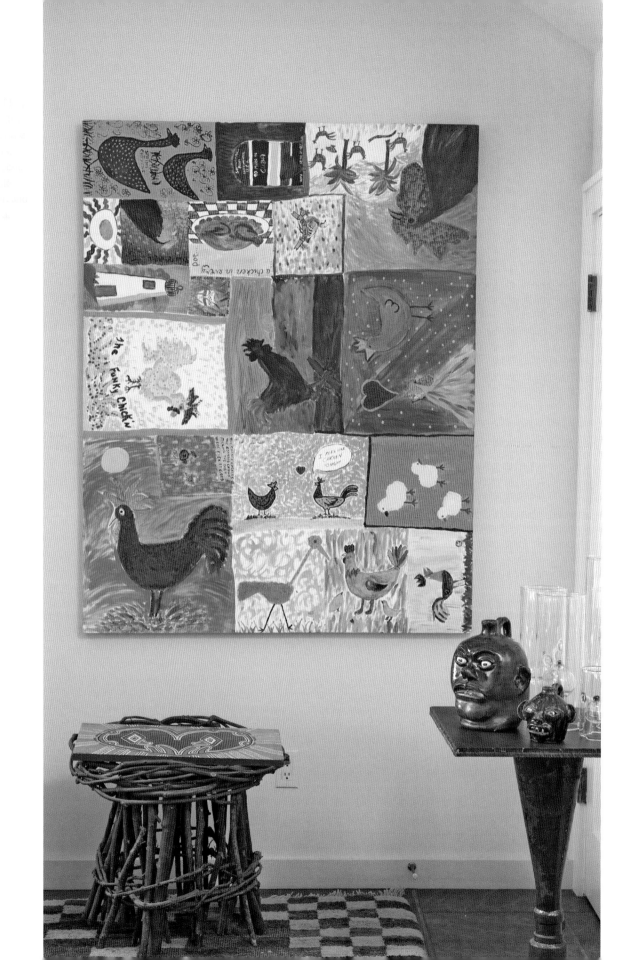

Korn says, "Richard has done wonders creating pocket gardens." Kemble, who attributes his green thumb to his British roots, cultivates orchids, which hang from trees and fences throughout their yard. He also maintains a vegetable garden in pots along a narrow pathway on one side of the house.

Kemble and Korn are antiques dealers specializing in early American folk art and marine collectibles. Over the years the two have amassed an eclectic private collection and have carefully selected pieces to use in their Key West home. "We often buy local art, especially at auctions to benefit social causes," George says. "For example, the painting of chickens that hangs in our living room was created by various artists in prison. The show, called *Art Behind Bars*, was held at the old Custom House at Mallory Square."

The two are also former restaurant owners, and the kitchen of their Key West home is a busy place. "We like to cook for close friends as well

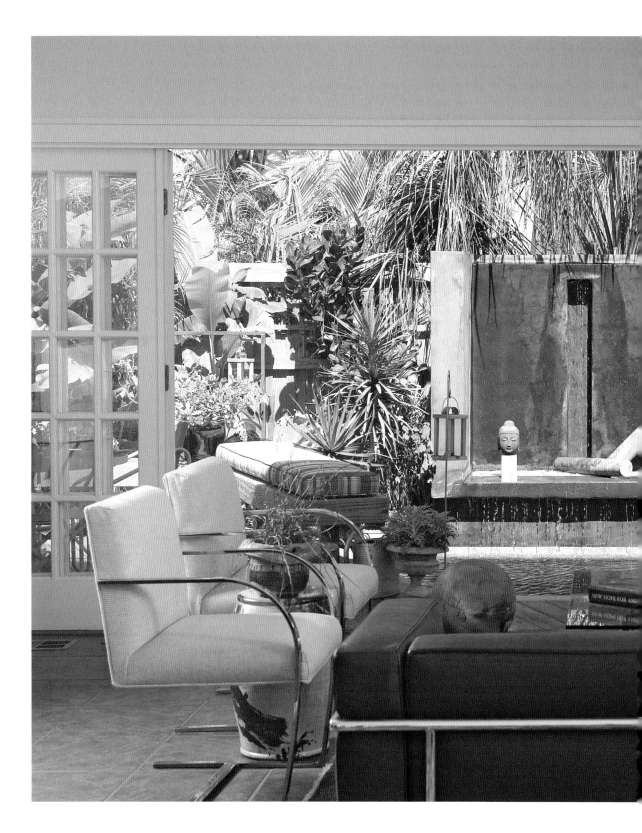

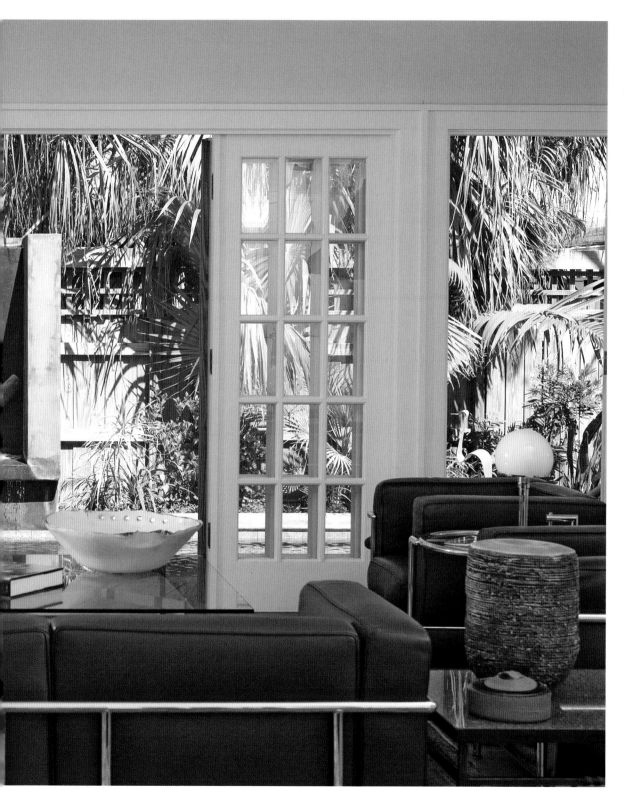

The sleek, modern
furnishings make striking
counterpoints to the lush
planting and sculptures.
The ceramic vessel is
by Rob Sinclair.

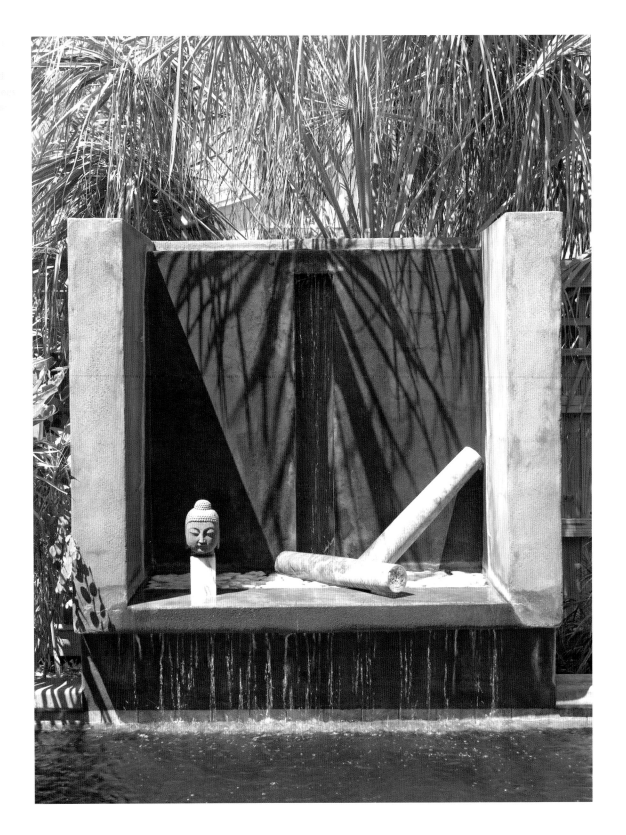

as planning a casual supper for a crowd. We usually invite all the out-of-town antique dealers for dinner following the Key West Antiques Show," George says. "The house flows well for these occasions."

Korn and Kemble live half the year in Key West and the other half on Nantucket Island in Massachusetts. Richard adds, "We don't leave until the middle of May, and when we arrive on Nantucket, the flowers are just coming up. I start working in my garden there right away." And so the cycle of perfecting their nest begins all over again. "But I do miss my orchids," he sighs.

left. The master bathroom is finished in black marble; the ceramic pot holding the orchid sits on a piece of slate that fits across the tub.

right. A stylish setting for the table on the deck. The centerpiece consists of sprigs of parsley.

Briefcases by Day
And Rock by N...

TO THE MANOR BORN

THE CLIMBING TRACTOR
IT CLIMBS OVER EVERYTHING
ANIMATE TOY COMPANY Inc. 5TH AVE NEW YORK

THE COUNTRY CLUB 1882–1982

RANDOM NOTES OF BOSTON

MEMOIRS OF A HIGHLAND LADY

MARY STUART

THE HIGHLAND CLANS SCOTLAND

ANCIENT SCOTLAND

Historic Hotels of SCOTLAND

Sloe Gin
Recorked Sept. 1923
Recorked Sept. 1955

THE HARVARD LAMPOON CENTENNIAL CELEBRATION 1876–1973

Looking Forward

532 MAGAZINE COVERS
NORMAN ROCKWELL
ABBEVILLE PRESS · RANDOM HOUSE

The American Country House · Peter C. Marzio

Artist Jon McIntosh is no stranger to Key West, having owned and renovated several houses over the last ten years. "This house is perfect for me," he says about his current home on one of the most desirable blocks of Frances Street, opposite the cemetery. "I bought this house because it had room for my baby grand piano," he adds. Just about one thousand square feet, the one-and-a-half story 1930s-style wood bungalow is comfortable, neat, and charmingly eclectic.

The house was already renovated when "Tosh," as he is known to his friends, moved in. "Michael just made it better for me," he says, referring to designer Michael Pelkey. "The house originally had four or five tiny rooms when it was built for the cigar makers who came to Key West from Cuba. It was later gutted and a family of four used it strictly as a vacation home. "I just made the house comfortable for year-round living," he explains.

The house may be small, but the open floor plan prevents it from feeling cramped. The front door opens into what was originally the living room, now occupied by the piano and a round glass dining table. Typical of most renovated Key West houses, a new living room and kitchen span the back and open to a patio and free-form dipping pool. A comfortable sofa faces away from the open kitchen, a large and wonderfully faded leather chair and ottoman provide a reading area, and a coffee table completes the furnishings. A hallway separates the living area from McIntosh's bedroom and bath, and a curved stairway leads to the loft area that serves as a guest room and a place to store paintings. His one-man shows at the Gingerbread Gallery on Duval Street are often sold-out affairs.

The density of population in Key West means that properties are close together, and while this may be one of the factors contributing to the closeness of the community, it also means homeowners seek to create privacy in their backyards. The entire back of

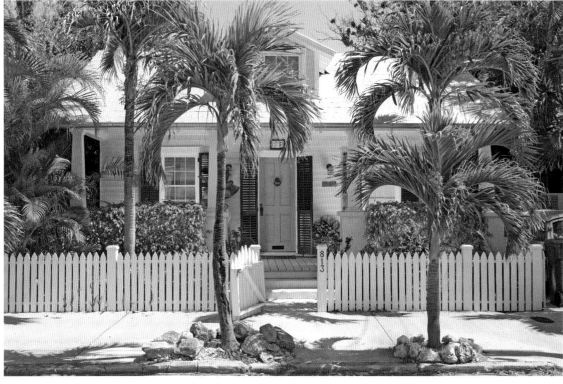

ON THIS SITE
★ IN 1897 NOTHING ★
HAPPENED.

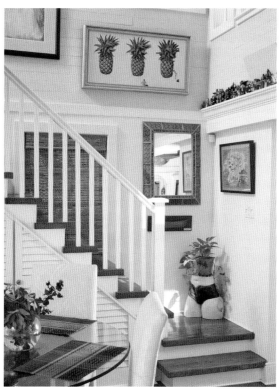

McIntosh's property is filled in with tropical plantings and a pool cabana, shielding the yard completely.

Inside, art and collections are everywhere. McIntosh built a wall of shelves across the living room to house his collection of books; the old samurai swords that belonged to his great-grandfather, a missionary in Africa; whimsical comic collections; Walt Disney collectibles;

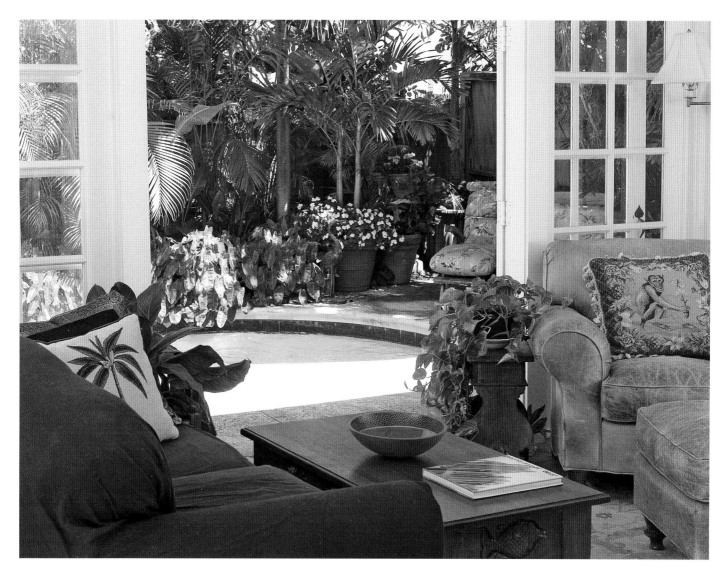

a small, cherished painting by his godmother, Ruth Fluno, a painter and poet; a delightful work by a Haitian painter; and framed family photographs.

Walls throughout the house are hung with McIntosh's own paintings as well as those of other local artists — some serious, some funky. Sculptures are deliberately and artfully arranged on the floor under the piano and on the stairway landing. This artist's tastes are varied, but he explains, "When you live in a small house and you are a collector, you have to be selective."

The small living room, open kitchen, and landscaped backyard provide comfortable living and entertaining quarters.

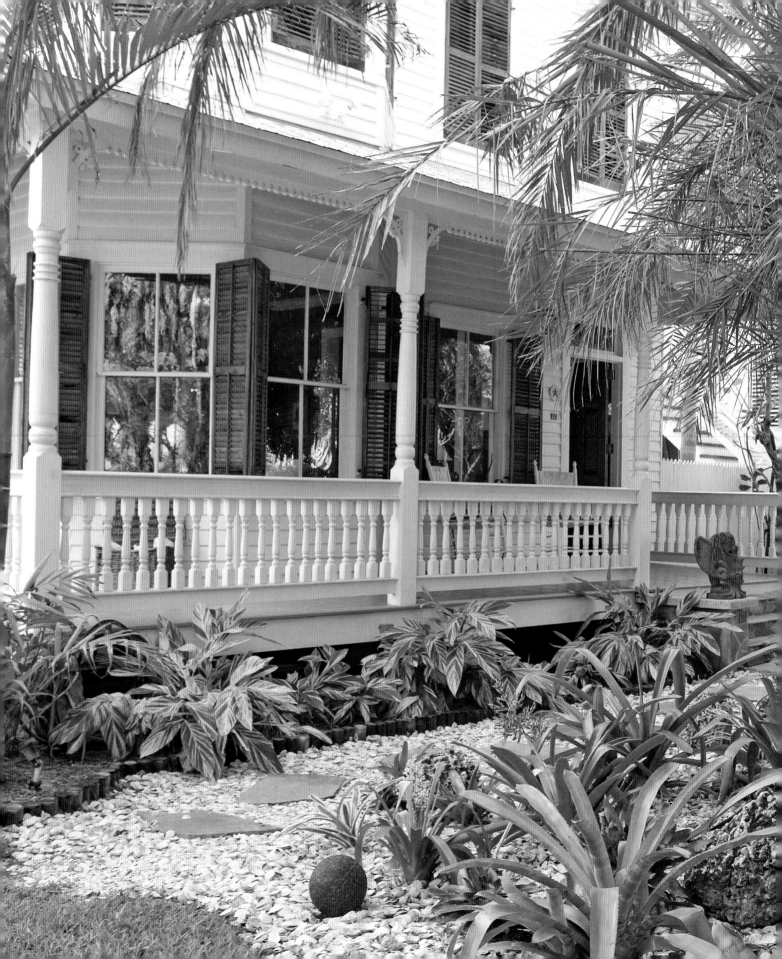

THE MEADOWS

The little square area bordered by Newton Street, Truman Avenue,
Eisenhower Drive, and White Street is a special part of the island known
as the Meadows. This lovely, quiet historic neighborhood just off to the
side of Old Town was once farmland. Key limes, vegetables, and dates
were cultivated for island residents and for commercial enterprises.
Chickens and cattle, too, were raised in this part of the island before
it was developed for residential use. Today, wood houses representing
a variety of architectural styles fill this family neighborhood.

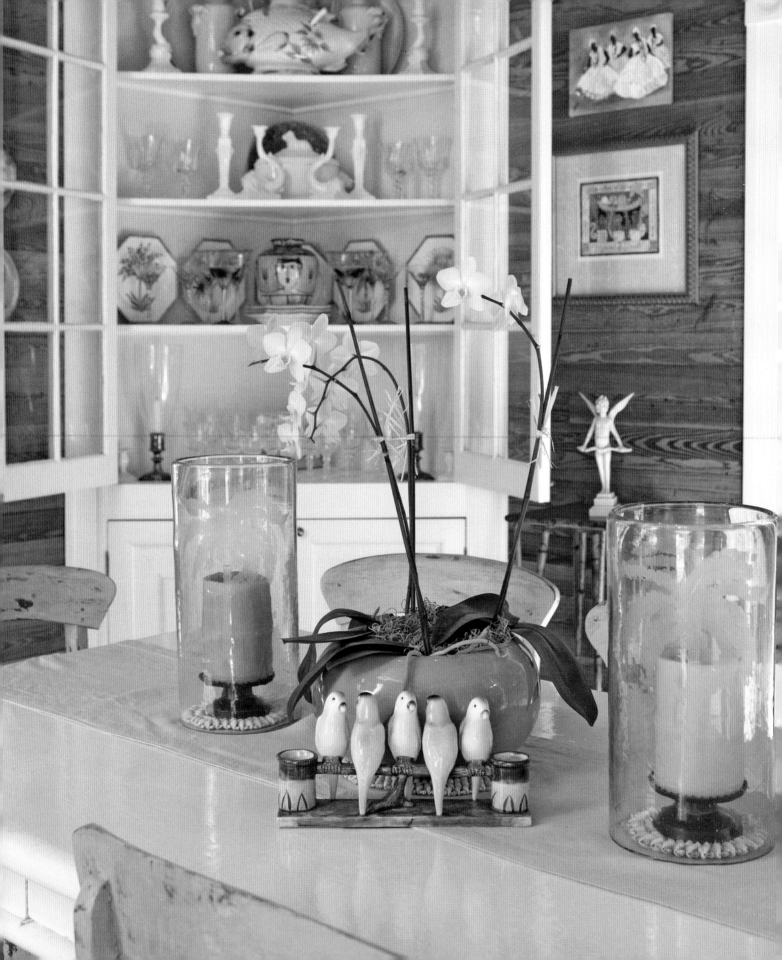

Palm Meadow

Named for the thirty-fourth U.S. president, Eisenhower Drive runs along the shore of Garrison Bight from Palm Avenue to Truman Avenue. Before the name change, it was known as North Beach Road, and the stretch near Truman was where Salt Pond Road began. The houses along this street were waterfront property until the navy bought Garrison Bight in the early 1900s and turned it into a protected harbor, siting their buildings between the harbor and the houses that once faced the water.

Opening the gate to Palm Meadow brings the visitor into a little piece of heaven. A unique house on one of the largest properties on the edge of Old Town, and one of only four houses on the island with roof turrets, it sits on a double corner lot. Palm Meadow was built in 1907, and its original owners harvested dates here to sell on the island. The drying racks can still be found under the house.

The current owners, Alan Van Wieren and Trip Hoffman, have been Key West residents for more than twenty years and own many houses on the island. Trip Hoffman heads a team of realtors for the Real Estate Company of Key West, and Van Wieren wears many hats as businessman, property manager, real estate broker, landscape designer, and former owner of a large chain of saddleries. His most recent interest is in collecting classic Chris-Craft boats, two of which they use in Saugatuck, Michigan, and two on Lake Lanier near their home in Tryon, North Carolina.

"The property has had only three former owners." Hoffman says. "When it came up for sale, someone suggested dividing it into several house lots. I couldn't let that happen to this beautiful property, and I'd always had my eye on it." Hoffman and Van Wieren tackled this project with enthusiasm. Hoffman says, "We like to cook, and we entertain a lot.

A lime green and white color scheme unifies the furniture and accessories in the dining room. The table is a reclaimed banker's desk from the first bank on Key West. A row of ceramic birds, candles in etched-glass hurricane lamps, plates with a palm tree motif, green and white china, a marble angel, and two paintings by local artist Michael Palmer adorn the room.

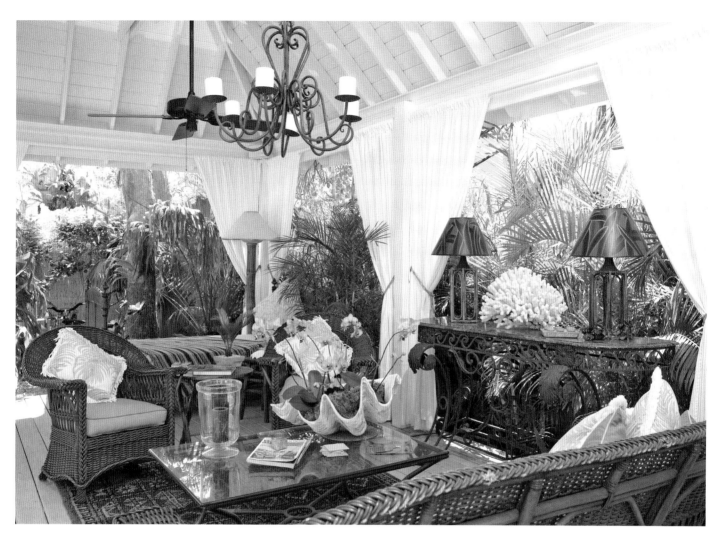

At Christmastime we have a lawn party. We invite about two hundred people, and the place is magical. Alan has done a great job with landscape lighting and people gather in the loggia and around the pool or mingle throughout the house."

But the house is more than that. It is personal, inventive, and sophisticated and, at the same time, homey. Hoffman and Van Wieren have a sense of style, a knack for putting the right elements together, and they know when something works. They have managed to design a home that is tastefully appointed without seeming planned, as if everything just fell into place. At every turn, some clever arrangement or solution to a problem or great piece of furniture makes you say, "How did they think of that?" or "Where did they find that?"—whatever

left Dade County pine on walls and ceiling contrasts with the white-upholstered furniture and white-painted wood trim throughout the house. The hexagonal living room and master bedroom above sit under the turret.

right The pumphouse over the original cistern has been converted into Alan Van Wieren's office. The old plank walls are exactly as they were a hundred years ago. It is furnished with Persian rugs, a worn leather wing chair, a massive antique desk, and lots of collectibles.

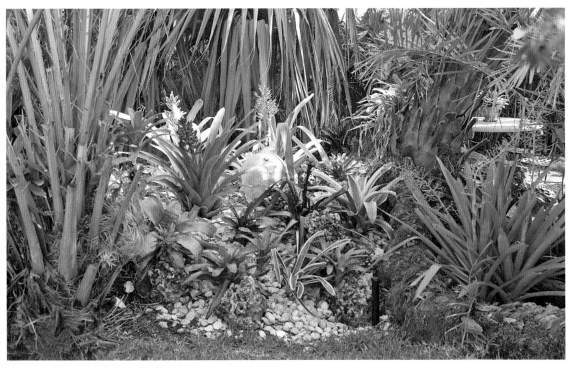

Red bromeliads, lignum vitae, and croton grow among the vast array of palm trees, including the Canary Island date palms and Bismarck palms. River stones and coral rocks create ground cover between the plantings.

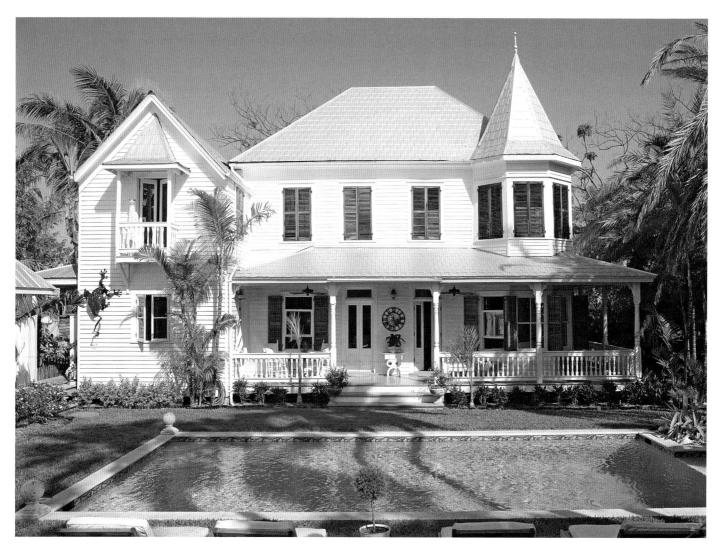

"that" might be. Van Wieren loves to shop and says, "Some of my best treasures, like the giant clam shell in the loggia, were found objects. They have the best yard sales here."

The loggia facing the pool is a new structure built at the edge of the property and resembles something out of *The Arabian Nights*. "We live out here," Van Wieren says. This structure serves many purposes. There's a bamboo bed, found at a yard sale, for relaxing and reading, an arrangement of furniture for cocktails, and a table for intimate dinners or breakfast with guests — always in attendance, especially during the winter season. Key West is, after all, the only place on the eastern seaboard to find consistently warm weather in February and March.

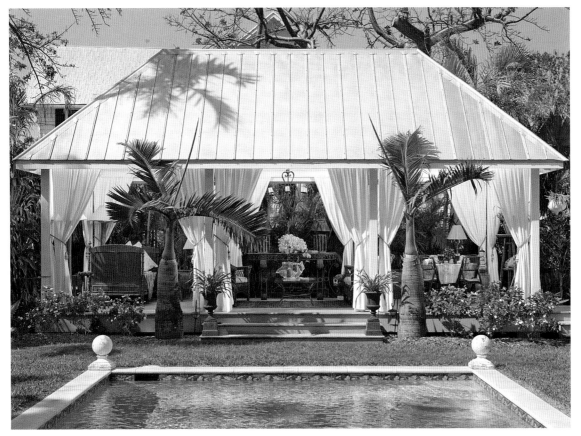

Hoffman and Van Wieren are masters of landscape design as well. After Hurricane Katrina they had to replace more than half the trees and plantings around the property, but the variety of mature tropical plants and trees makes it nearly impossible to believe the property has not always looked this way.

When not on the island, the two men might be fox hunting, traveling, or spending time at their home in Tryon. Hoffman says, "I just designed a camp there, and it was so much fun. I'd never done anything like it. I bought all the books I could find on rustic and Adirondack style and created a wonderful camp with bunk beds and twig furniture. It was a rewarding experience, and our nieces and nephews fill the place all summer." This pretty much sums up the attitude of Van Wieren and Hoffman. They have found balance in their lives with plenty of time for work, play, friends, and family no matter where they land.

The guest bedroom is always at the ready. The Juliet balcony overlooks the pool, and the painting over the bed, *Wait For Me*, is by Michael Palmer.

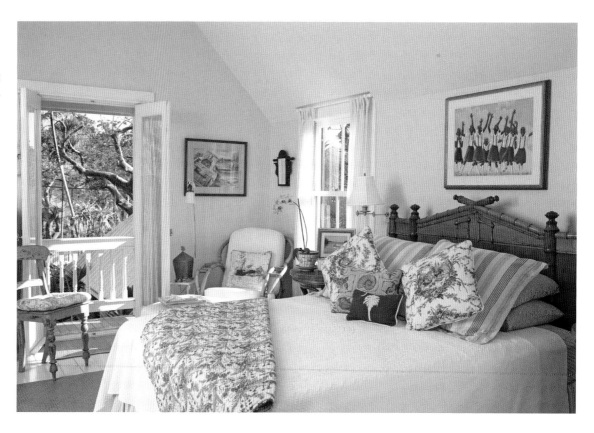

left Buckwheat has free run of the place and his own special entrance.

right The kitchen windows reveal the palm trees and exotic plantings that line the pathway to the gate.

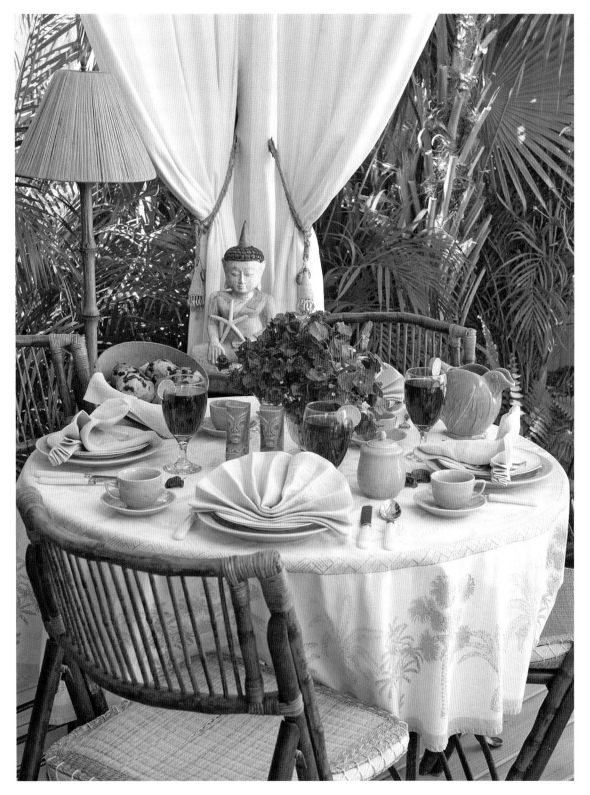

Two for One

One house would not do for Barbara Sowers, but turning two houses into one works just fine. "They were two little Conch houses, one behind the other," she explains. "I first came here in the 1980s and bought one for my brother and his wife and kept the other for myself. Like so many first-time visitors I never, ever intended to live here at all. I thought of it as Key Weird. Then my brother left and I thought about selling the houses. But you know how it is. Key West sort of creeps up on you and suddenly you realize you fit in and you find you're enjoying a lifestyle you didn't know you wanted." That's how Sowers, a former emergency room doctor and, later, attending physician for the Kentucky Derby jockeys at Churchill Downs, came to live in Key West. For much of the year she enjoys the life of an early retiree, playing golf and keeping active with her "walking club" of four regulars. "We meet early in the morning and do the four-mile beach walk and on Saturday we have breakfast at Blue Heaven or Sarabeth's," she says, referring to two popular local restaurants.

Located in the area known as the Meadows, the two houses have now become one, with a dining deck connecting them, for a total of about 1,100 square feet. "I turned the little kitchen of one house into my office," she says of the back house, which also contains her bedroom and bath and a sitting room that opens to the deck. The front house faces Florida Street between Olivia and Pine and holds a dining area, kitchen, bedroom, and bath. All the rooms open onto the surrounding deck and the pool.

The dining table on the outside deck is set with blue and yellow, lots of shells, sunflowers, and Sowers's prized possession, her hole-in-one golf ball.

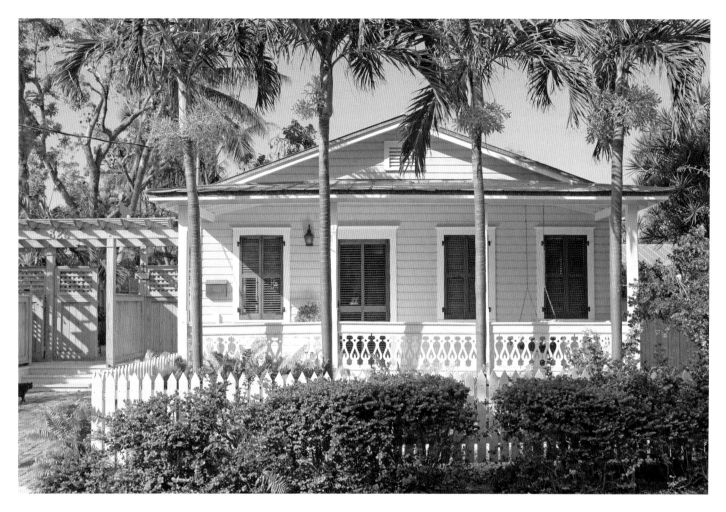

This type of structure — rectangular, one-story, wood-frame, usually a single room wide, with a roof ridge perpendicular to the street — is found all over Key West. Often no more than twelve by thirty feet, several of these structures, built initially to house the growing worker population of Key West, could be placed on a small lot. This building style was common in the southern United States during the late nineteenth century.

The living room is furnished with Heywood-Wakefield tables and chairs with a sprinkling of palm-frond green and white printed fabric. A painted chest serves as a divider between the living room and the eating area off the kitchen. There's always a bowl filled with fresh fruit on the coffee table and a large glass jar filled with oranges on the dining table. A painting by Michelle Castro fills the back wall of the open room where kitchen, living, and dining

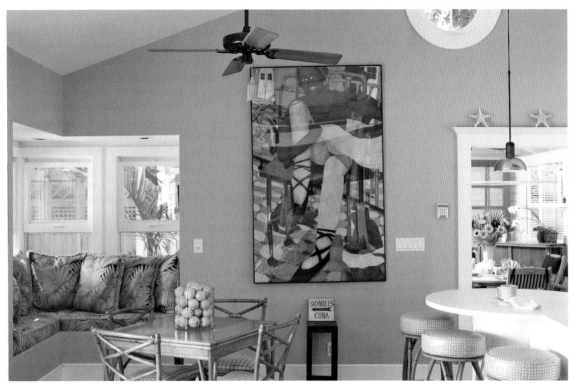

In the front house is a living room with kitchen and dining alcove. Starfish line the molding atop the doorway.

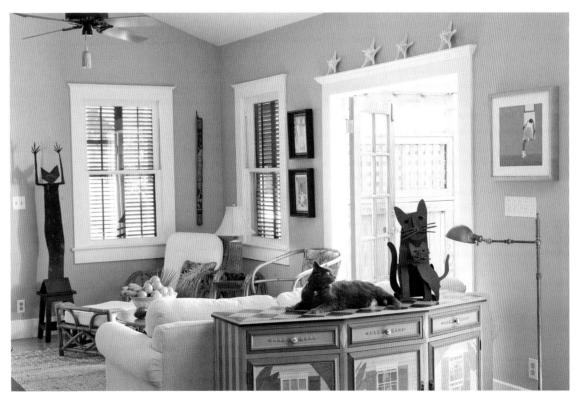

The living room is simply furnished with bamboo Heywood-Wakefield furniture. The metal cat sculptures were found at one of the island's art fairs.

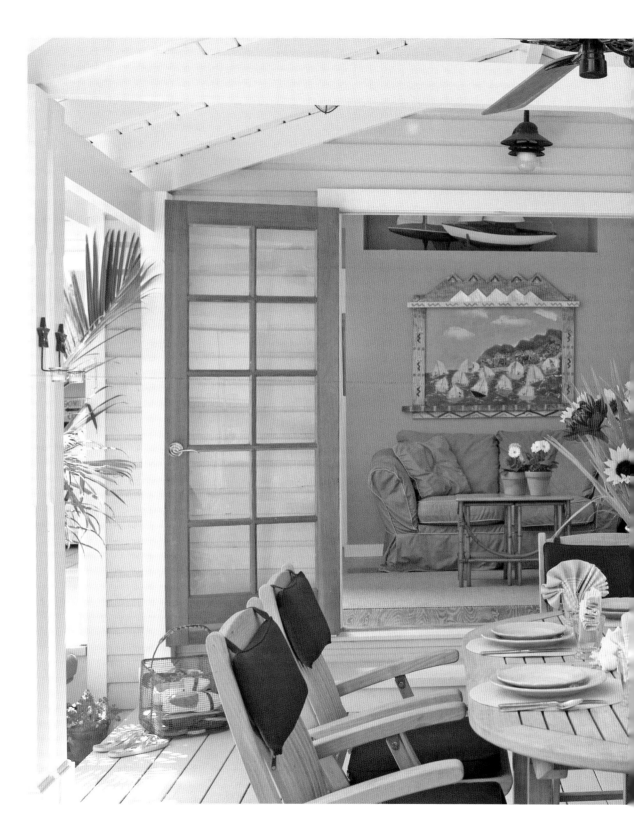

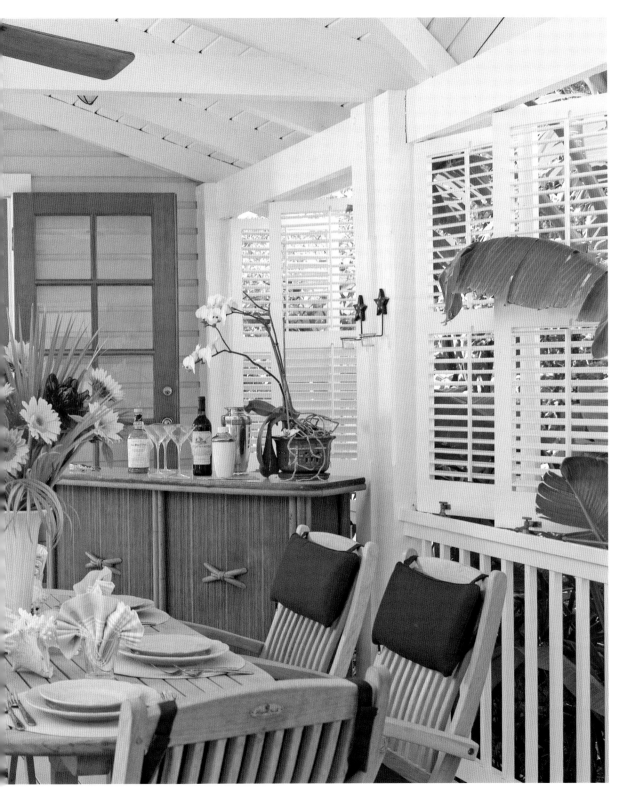

Barbara's office opens onto a small porch overlooking the pool. The fence and border plantings separate her property from the houses around her in this tightly knit neighborhood.

areas converge. Paintings by Michael Palmer and other local artists also decorate the walls.

Sowers finds that her life is very full "because Key West is part of the equation. The people here are special. They're intelligent, quirky, fun, interesting—in short, it is a diverse community." And again that word crops up: "community."

Like many residents of Key West, Sowers is a cat lover. She describes one of her cats, Gracie, as "shamelessly social, often making herself right at home in my neighbors' homes as if it is her absolute, God-given right. Gracie often precedes me at social get-togethers. I'll arrive and there she'll be, lounging on someone's kitchen table, perfectly at home."

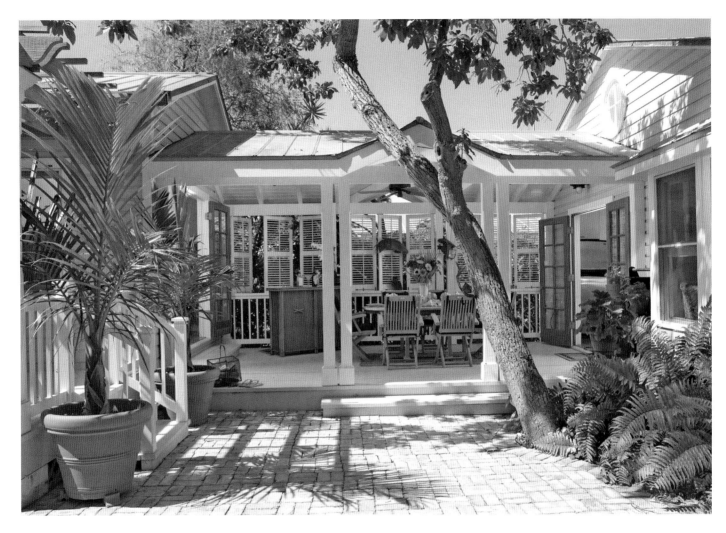

Now that her life is more in balance than it ever was when she was working, Barbara Sowers has become just as comfortable in her new hometown of Key West as she is in her old hometown of Louisville, Kentucky. Her brother and his family visit during the holidays, and his kids "have a great time," Sowers says. Maybe someday she will be a full-time Key Wester, but for now she has plans to travel and is not ready to take retirement lying down.

The outdoor deck joins the front and back houses. Custom louvered shutters along the back porch railing control weather, sunlight, and privacy. Stairs at one side lead to Sowers's office, and a mature avocado tree shades the brick patio.

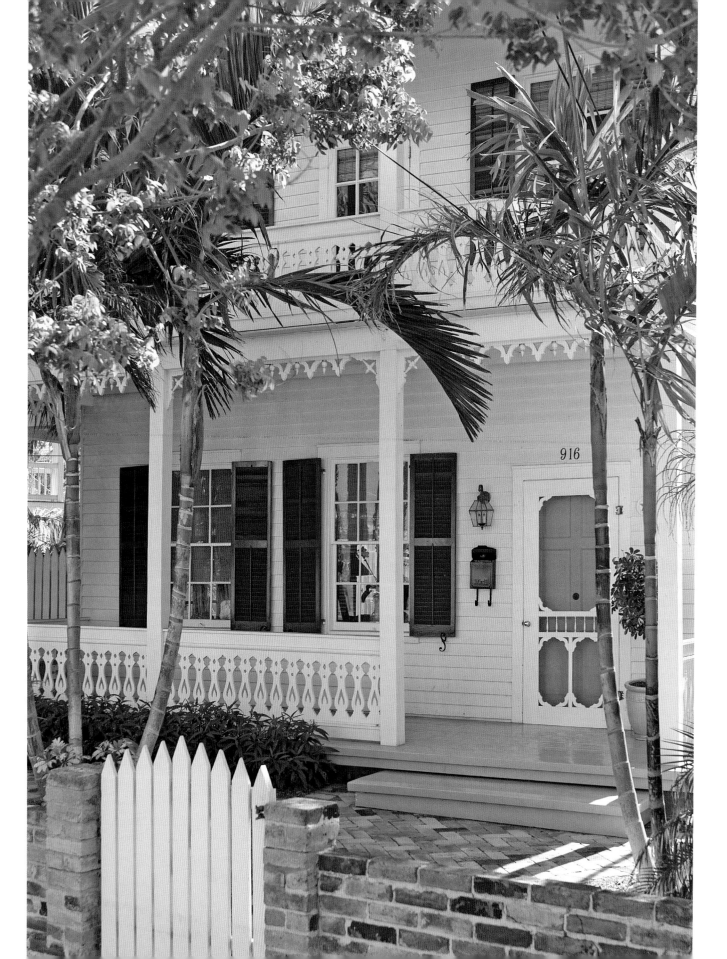

In the Classic Tradition

The house is located on what some call a fun block of Eisenhower Drive due to the many interesting characters who once inhabited these houses. There was the fan dancer who lived in the house next door, and the owner of Key West's most famous bar, Sloppy Joe's, lived in another. This two-story, three-bay Classical Revival structure was built in the 1890s during a construction boom in Key West. The house is side-hall in plan and has the steep roof common in Key West, as well as first- and second-floor wraparound porches with gingerbread trim that are accessible from every room, another typical feature in houses in Old Town and the Meadows.

Owners Blair Gordon and John Alvarado are partners in life and business. Their design firm, Gordon Alvarado Real Estate Design and Development, is based in New York City, but they have renovated many houses in Key West as well as in the Hamptons, on Long Island. This team has put a new spin on the practice of renovating historic houses for resale by creating individually designed homes for people who appreciate good design but do not have the time or inclination to do the project themselves. Once a house has been renovated, the firm styles and furnishes it, even hanging artwork on the walls and filling the bookcases with books, so that each item is just right for the space—perfectly to scale and in harmony. Sometimes this means designing their own furniture. "We design the house the way we think it should be, as if we were doing it to live in ourselves, and that's exactly what we do before selling it. When we live in the house, we can work out all the details and anticipate what is needed for everyday living. The new owner is buying a complete lifestyle. If someone can imagine living in

This Classical Revival house has two levels of wraparound porches with gingerbread trim. The front walk of old brick laid in a herringbone pattern leads to the front porch, painted glossy gray.

Built-in shelves and cabinets in the living room hold carefully selected objects. The black-and-white photograph is a "reverse" portrait of Blair Gordon. The barrel chairs were found at a Paris flea market in the 1980s.

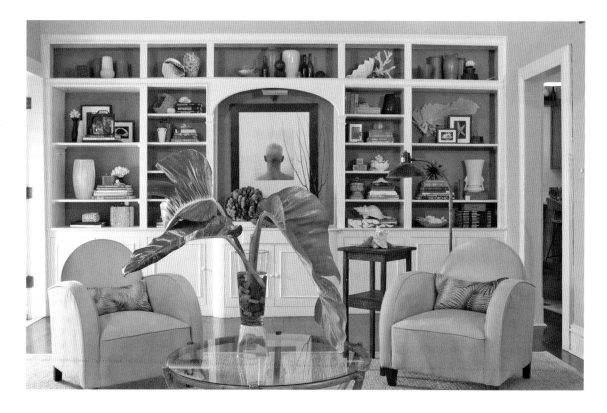

The covered porch overlooking the pool is part of the new addition. Even though properties are close together on Key West, the new landscaping creates a wall of privacy. Blair says of the room, "It is a blend of East meets West, or 1950s Zen meets the tropics."

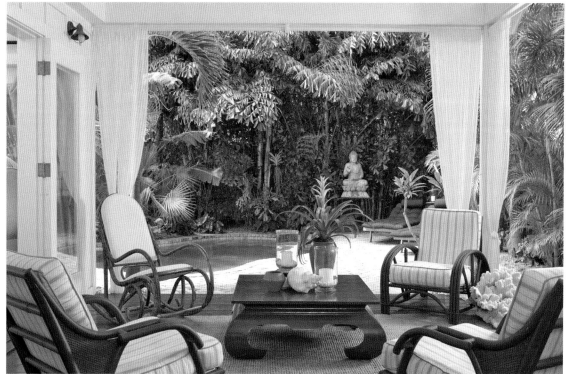

the space and there's a fit, then the project is a success," Gordon explains.

When they bought this house, they called in local architect Guillermo Orozco to design an addition in order to expand the living space. "But we didn't change the architectural style. We just added a porch and a master bedroom and bath at the back of the house. We also designed the pool and landscaping."

Gordon began his career in design as creative director at J. Crew. He was there for eleven years and then became vice president of creative services at Ralph Lauren. John takes care of the business end of things. Gordon describes their process. "Every design project is a challenge. I always begin by thinking through the details of how each room will be used. With clients I talk conceptually about the house and try to formulate a plan. I ask questions to get a sense of how they live. Do they entertain? Do they have hobbies? And I did the same thing with this house, making it the perfect getaway house for us. When we walk in, we're instantly relaxed, and we can entertain, work, or do nothing here. If it works for our lifestyle, there will be some-one who feels the same way about the house."

A "shelfscape" of collectibles demonstrates how Gordon and Alvarado work with colors, shapes, and textures.

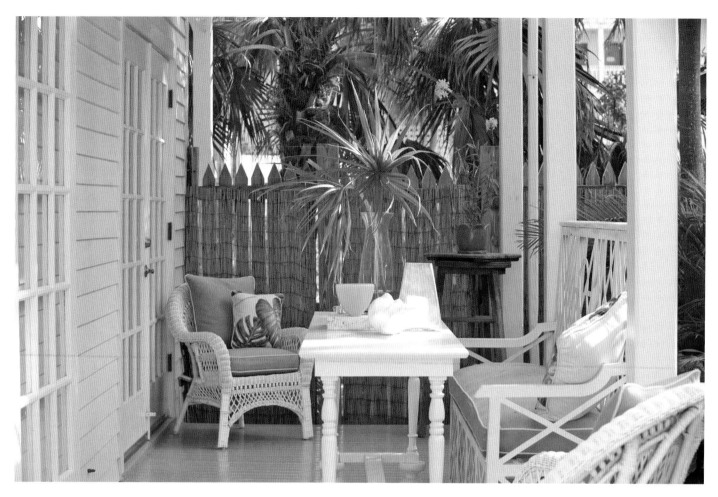

Like many houses in Key West, this one was designed for carefree, low-maintenance living. The furnishings are deliberate and spare, but at the same time the space is sensuous, with soft colors and shapes and many tactile objects. The various colors of nature work well here, such as coral or the subtle shades of shells. The walls, floors, and furnishings are muted shades of cream mixed with dark brown woods that contrast with crisp glossy white trim and

bright green accents. The result is sophisticated without a hint of pretension. Arrangements of collectibles and art are concentrated on built-in shelves and on walls, with select pieces carefully placed throughout the rooms. "If you come into a room and need to hang your hat," Gordon suggests, "put a wonderful bamboo coat rack on the wall. Work it into the arrangement of art. Make every piece an artistic decision." And then he adds, almost tongue in cheek, "A beach towel

126

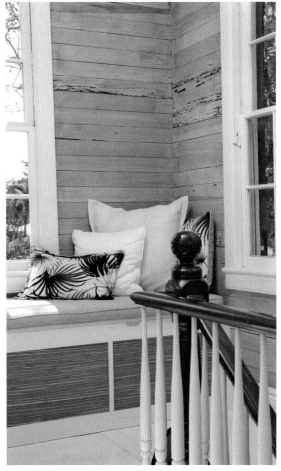

will inevitably end up thrown over a chair, so be sure the color of your towels matches the color scheme of the room."

The layout is typical of many houses built in the late 1800s in Key West. A stairway hugs the wall of the long, narrow hallway that begins at the front door and continues through to the kitchen at the rear. The living room to the left in the front of the house opens onto a side porch. Gordon says, "This house had great bones. We simply took what was already here and brought it back to life by scraping away the layers of neglect."

When asked about their favorite project, Gordon says, "They've all had challenging aspects, but the best ideas come from not having an endless budget. It's fun to put boundaries on a project, and solving problems offers the opportunity for creative solutions."

CASA MARINA

The Casa Marina Hotel was built by the Flagler chain and opened
on New Year's Eve, 1920. The Mediterranean-style resort hotel stands
on expansive grounds with five hundred feet of beachfront property.
The hotel had fallen on hard times over the decades, and the Wyndham
Resort Chain has restored it to its former grandeur. The streets that
border the hotel and are within easy access to the beach and town form
an upscale neighborhood of concrete houses built predominantly in the
1950s. There are still many homes built in the early 1900s here as well.
The lots are larger than those in Old Town, and the houses in this area,
known as Casa Marina, are perfectly suited to contemporary renovation.

Color Works!

Key West has been home to real estate agent and author Lynn Mitsuko Kaufelt and her husband, novelist David Kaufelt, for more than twenty years. They raised their son, Jackson, here, and over the years they have been involved with many local organizations, giving generously of their time and talents to support local causes. David is the founder and president of the Key West Literary Seminar, and they both donate time to their pet project, "Take Stock in Children." They are a couple with tremendous community spirit who have woven themselves into the fabric that is Key West.

Lynn describes what makes their house special: "We like the Casa Marina area. There's elbow room in this part of town." She continues, "And we can still bike and walk to Old Town. A CBS (concrete block structure) house is low maintenance and all on one level. On this corner we see the hotel, and there's lots of activity." David adds, "People are always walking by the house. I work at home, so I like to see and feel the activities of life going on around us. This city is a microcosm of New York City, with all walks of life. Key West equalizes people."

Lynn is one of the three partners who own Truman & Co., an active real estate firm on Truman Avenue. When this 1918 house, which sits diagonally between Casa Marina Court and Reynolds Street, came on the market she immediately recognized its potential, and the couple hired local architect Rob Delaune to redesign it for their lifestyle. "We both have strong ideas, and we usually agree on houses. We really enjoy doing it," Lynn says. In addition to restructuring the interior, the Kaufelts did not hesitate to change the beige exterior to its colorful new facade. "Debra Yates helped us choose the colors.

The wrought-iron gate artfully announces where guests should enter.

131

Local artist Debra Yates
created the ceramic wall
facing the pool.

She also designed the circular driveway and planned how to get in the front door. It was a tricky thing," Lynn explains. Yates is a muralist whose work is seen all over Key West. She designed the mosaic that spans a section of the retaining wall along Smathers Beach. As part of the renovation she created a mosaic wall along the back of the Kaufelts' house. This versatile designer also had a hand in planning the garden, working with landscape architect Rob Newman.

The exterior is an exciting standout in this neighborhood of one-story, gray concrete houses. But the outside is just the beginning. Open the front door and you enter an exciting world of color. Before becoming an author (*Key West Writers and Their Houses*) or realtor, Lynn was a color consultant for a cosmetics firm. That experience and their travels to Morocco, India, and Indonesia have influenced her assertive and highly effective use of color.

The house is not large, but the open floor plan gives it spaciousness, and there is more room than at first meets the eye. Stone tile floors are used throughout, with no carpeting to break up the continuous sleekness. Rooms flow into each other, with the delineation of space achieved by a change of color.

"We relocated the kitchen from one side of the front door to the other so it would be larger, and we now use the old kitchen space as our dining area. We took out walls so everything is open, with the living room straight ahead and pocket doors that open up the entire back wall. We added a new deck and lap pool with a fountain," she says. The variety of palm trees and flowering shrubs creates a living painting seen from inside the house. Lynn likes to putter in the garden, although she admits she is interested only in the finishing touches. The black-and-white-striped awning protects the living room from sun and the occasional rain shower.

The color of the new kitchen walls might be described as pumpkin, but Lynn confirms that it is actually called "Yam." One countertop is Corian, the other a slab of marble. "We display

This colorful one-story concrete house sits catty-corner from the Casa Marina resort hotel.

133

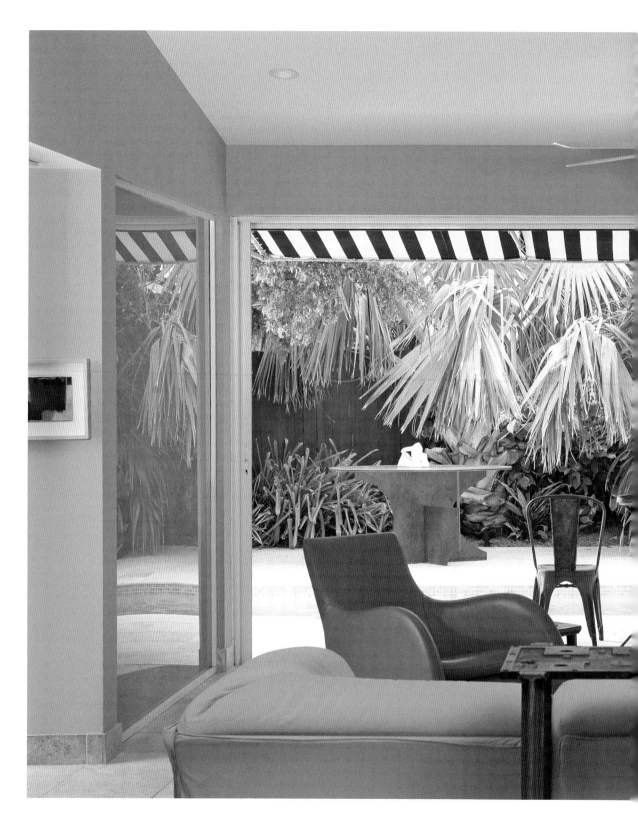

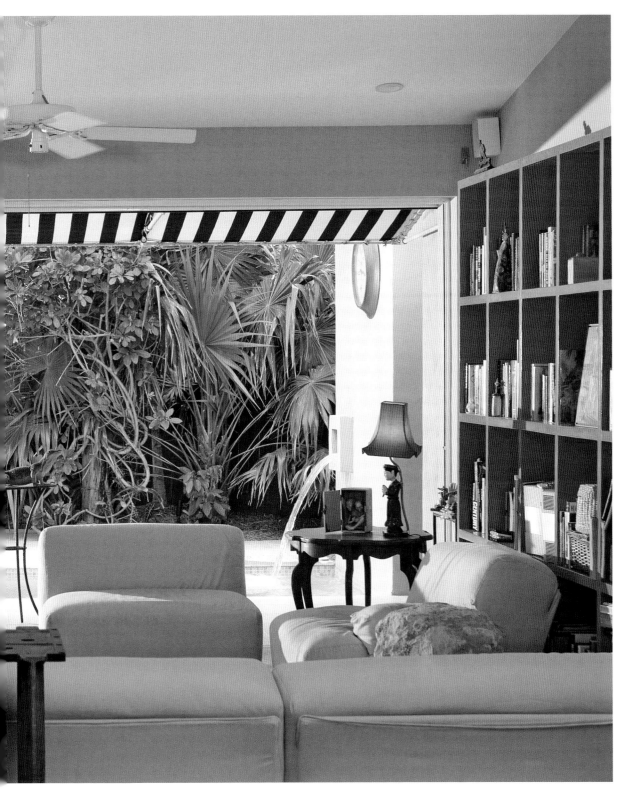

The living room wall
opens to the outdoors;
a wall of exotic plantings
creates a living artwork.

objects of art here when we aren't using the counter for entertaining," Lynn says. A wall of navy blue cabinets and a bar area fill the other side of the room.

A hallway off the kitchen is painted pale avocado and leads to a gray slate bathroom and guest bedroom. Beyond, a small patio area, big enough for a table and chair, is made private from the street by a fence of orchids. "This is my mother's room when she visits," Lynn says.

A wall of bookcases in the living room is painted an unexpected terra-cotta, and to the right of the living room, the master bedroom suite is painted bright red enamel with black accents. There are two more small rooms: a bedroom and adjoining bathroom for Jackson and an office for David. A glass wall separates the office from the living room.

"My favorite details in the house," David says, "are the two movable walls across both

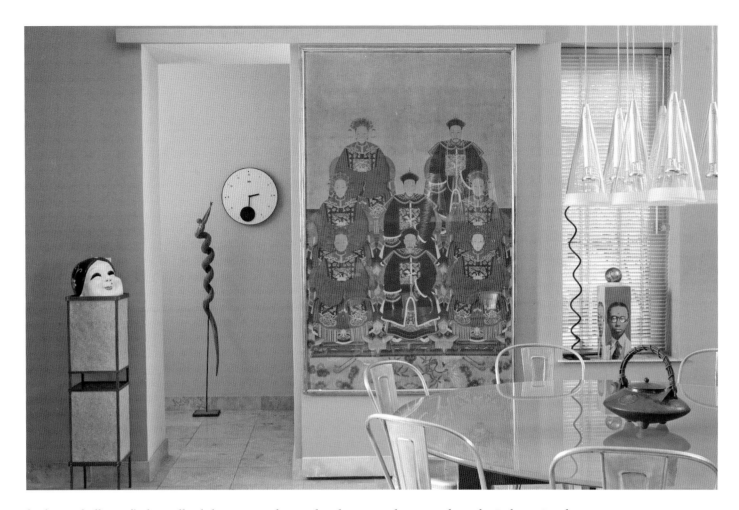

bedroom hallways." The walls glide open or shut on tracks. "We've done this before. It's a little bit of influence from Charlie Chan movies," David says, revealing a wry sense of humor. On each wall hangs a painting. "We've had the Asian painting since Jack was born. We always told him the portrait was of his ancestors," Lynn says, smiling. The Kaufelts' quirky, playful approach to art extends as well to the rest of their house, which is filled with the work of local artists. They own chairs by Roberta Marks, whose sculptures are in numerous public collections, a sculpture by Duke Rood, and a table by award-winning sculptor Cynthia Wynn, whose work has been featured at the Wave Gallery on White Street.

In the dining area and throughout the house, Asian art mixes easily with work by local artists. The dining area is where the old kitchen was located. The wall slides open to reveal the bedroom suite beyond.

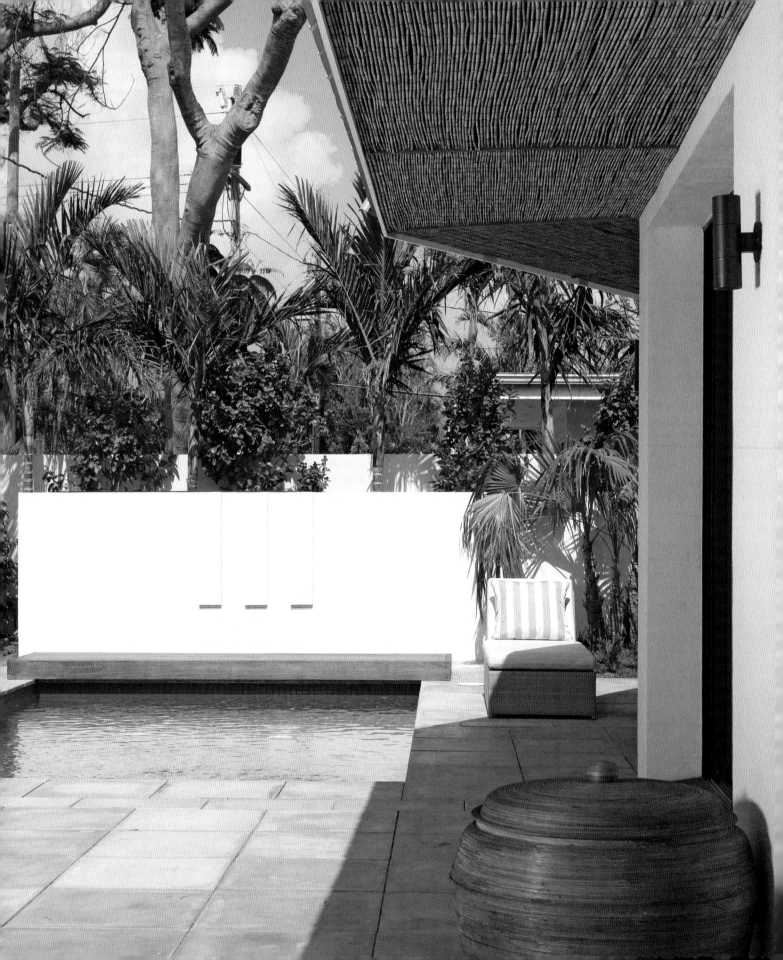

Contemporary Casa

With the agility of a boy half his age, interior designer Alexander Baer hoists himself up onto the kitchen counter to adjust an overhead light bulb ever so slightly. This particular action says it all. His attention to detail is an innate quality that he brings to every interior design project his firm takes on. He is the consummate perfectionist. This time, though, Baer is experiencing the joy of putting the finishing touches on his own home. "This is the second house I've owned in Key West," he says, "and entirely different from anything I've ever designed before."

When Baer found this one-story concrete-block house in the Casa Marina area, it was already undergoing a renovation. Local builder Greg Tolan, who grew up in Key West and has renovated many houses, was not too keen about selling the house to Baer before it was finished. "He talked me into it," Tolan says, "and offered to collaborate. Then he told me his ideas. And while I consider myself a designer/builder, Alex is a true master of style and taste. Working with him was an incredible learning experience. It really made me grow."

Alexander Baer Associates, an interior design firm specializing in residential interiors, opened its doors in 1972 in Baltimore, Maryland, where Baer grew up. Today, this internationally known company, with twenty-six employees, maintains offices in Baltimore and New York City and has clients worldwide. "Our office has a bit of a camplike environment," says this man who, at the moment, looks like a camper himself, dressed as he is in khaki shorts and sandals. "In order to grow, it's important to respect the people who support you and execute your designs. I have great respect for everyone in my office."

"This project was different from any other I've done," he says. "My apartment in Baltimore is quite traditional and filled with antiques. My house at Fire Island is designed

Gray slate tiles surround the pool, and a wood bridge spans it. There is a shallow dipping spa at the far end.

Modern meets Asian in the living room. Glass walls slide into wall pockets so that the back of the house can be completely open. The two yellow paintings, oil and wax on wood, are by Julie Ouellet, and the painting over the banquette is by Friedel Dzubas.

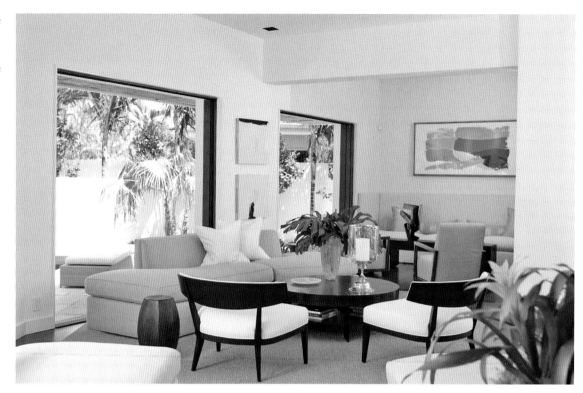

Sleek cabinet doors hide all kitchen equipment. The pale aqua cabinets play off the green granite countertop.

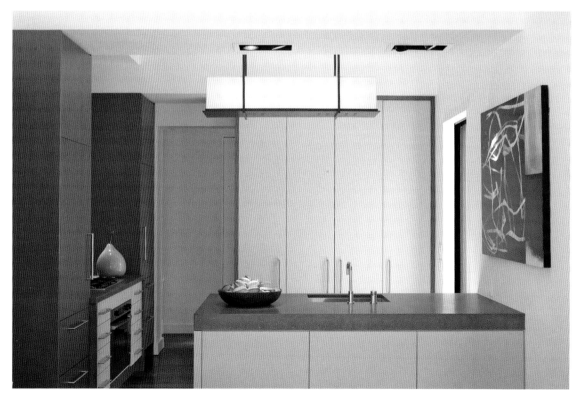

High ceilings, wide windows, muted colors, Asian furniture, and sisal carpeting define not only the master bedroom but also the rest of the house.

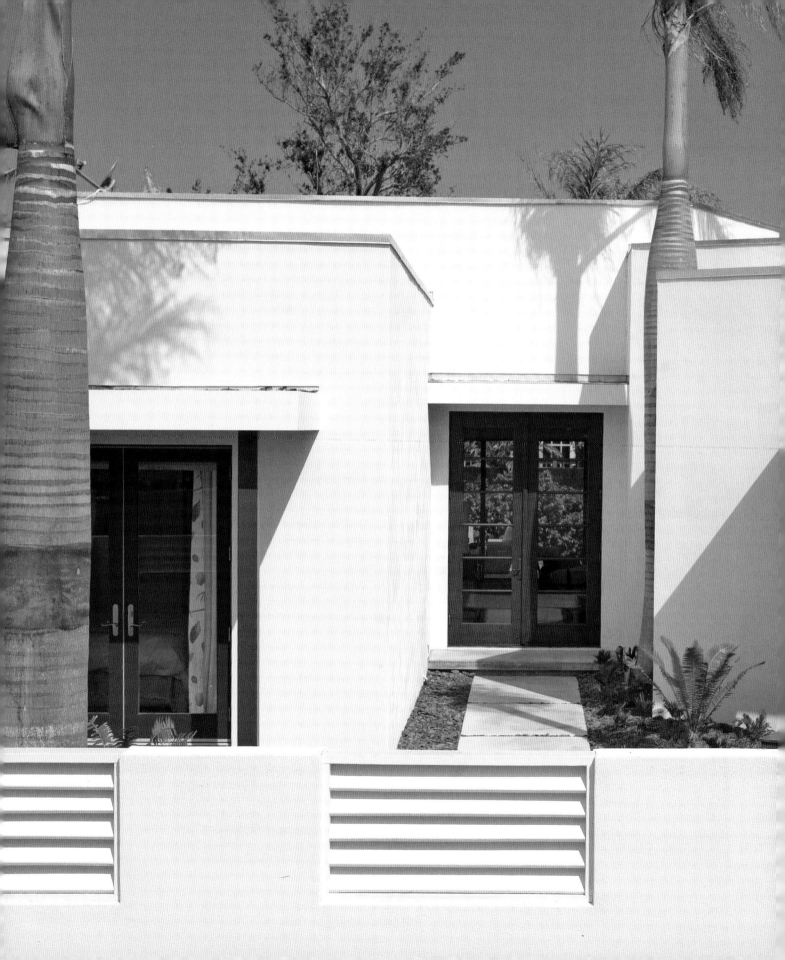

strictly for summer living. The hardest thing
I found with this project was to build and design
minimally. A house is never perfect, so it's even
harder to do it for yourself. You know you'll have
to live with your mistakes. I usually pretend
I'm not the client."

When asked what he likes best about the
house, he answers, "I really analyzed how I would
live here. I wanted simplicity. Our lives tend to
be complicated, especially when you're in the
service business. I'm always concerned with
things being right for my clients. So this house
was designed for tranquility and ease of living."

The concrete-block, 1950s houses in
this area, with their long, low lines, are easy to
visualize as contemporary renovations. While
this house has been completely transformed,
the footprint is the same as the original. No
space was added, it was simply reconfigured.
Replacing windows and interior walls with lots
of glass opens up the rooms and, in keeping with
the proportions and scale of the house, there is
no trim around the openings.

Glass front doors open into the entryway,
where a large cabinet holding two white ceramic
vases and a contemporary painting above
immediately makes a bold statement. Beyond,
the living room fills the full width of the house.
Ceilings are high, doorways are wide, glass walls

The concrete-block
structure was
completely renovated
by builder/designer
Greg Tolan and owner,
interior designer
Alexander Baer.

disappear into side pockets, and the details throughout are lavish. Dark stained wood floors contrast beautifully with the soft hues of the walls and furnishings. The furniture, colors, and materials create an aura of understated elegance reminiscent of 1930s Hollywood, but with a modern interpretation. Every object is carefully placed so there is breathing space around each one; two yellow silk pillows on the built-in banquettes pick up on one of the colors in the painting above. When I comment that the sculpture on the table is perfect in the room, Alex says, "I wasn't looking for anything special. We were walking by a gallery in town and I just spotted it. It isn't of any particular value, but that's what good design is about. It's the ability

to use the old with the new, antiques that are really good with that which has good lines but is of no particular monetary value." The trick, which this designer knows all too well, is to marry different styles and provenance so that everything is of a piece. Alex says, "A person has to be very knowledgeable to distinguish the difference. One good piece elevates all the lesser pieces," he adds confidently.

Alexander placed his desk at one end of the living room. "With every other house I've owned I worked around the house and made do for my work space. When I did this house, I started with a different concept," he says. "I based the design around where I wanted to sit and work. I put myself in a spot to appreciate

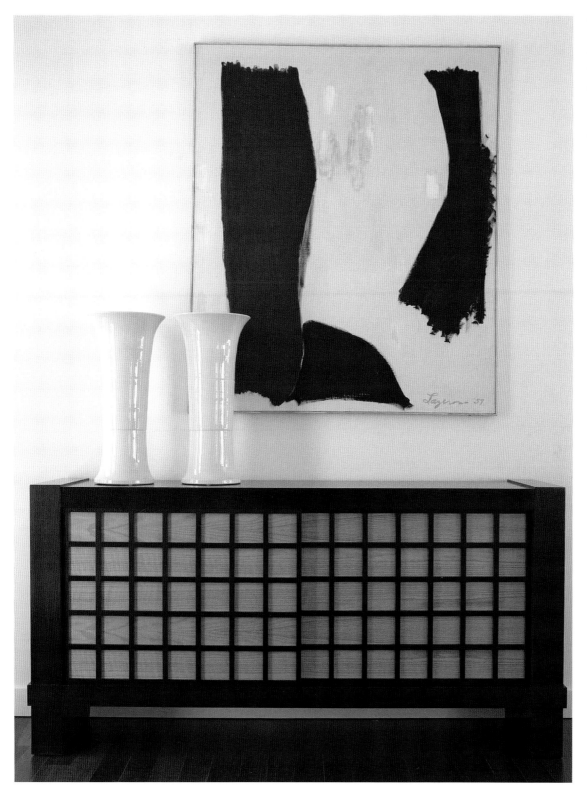

The entryway sets the stage with simplicity. One large piece of furniture, oversized ceramic vases and a bold contemporary painting make a dramatic statement.

The end wall of the living room where Baer has positioned his desk opens completely to the outdoors. Cushions made with weather resistant pumpkin-colored fabric fill the outdoor banquette.

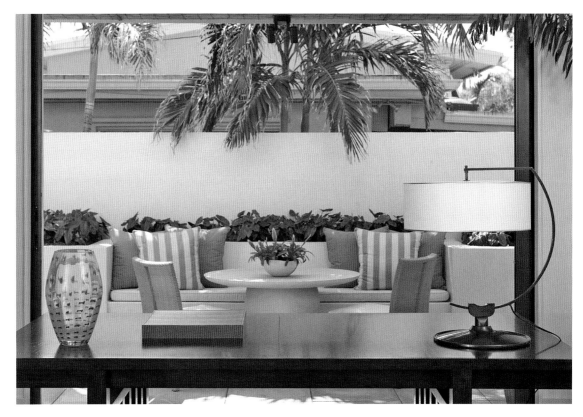

the architecture of the place and the outdoors. From here I have the best view of everything."

The kitchen is open to the office end of the living room and separates a guest bedroom and bath from the rest of the house. His own expansive bedroom suite occupies the opposite side of the house, allowing complete privacy for owner and guests. All rooms open to the outdoors. The eating and sunning areas wrap around the exterior of the building, enclosing the pool, with plenty of privacy provided by a high concrete wall as well as ficus trees and bamboo plants. Tall palm trees define the property, however, and Alex says, "Landscape

architect Craig Reynolds is brilliant. He totally understood what I was after."

Alex likes to spend as much time as possible in Key West. "I'm quite organized, so I block out specific times to be here," he says. "Starting in October, I come down at least once a month, and then stay for the last three weeks in March. My clients travel as well, and they know when I'm available. I can completely leave the real world behind me when I'm here. Islands are like that. I find I'm more creative and do better work because I have Key West." He concludes, "I am very fortunate that I get to do something I adore every single day of my life."

Sleek, modern and amply appointed, the bathroom is designed with everything needed for excessive pampering.

Southernmost Living

Like many people who come for a visit, Nancy and Tim Grumbacher had no intention of buying a house in Key West. "But Tim and I love looking at properties. It's one of our hobbies. And Alex was already living here," Nancy says, referring to her friend interior designer Alexander Baer. One of the properties they saw was on a deep double lot, and the house had already been renovated. It was in perfect condition and was ready to be decorated, a passion Nancy and Alex share. "I've decorated several homes for Tim and Nancy, as well as their children, and the minute we stepped up onto the porch I knew this house was perfect for them," Baer says. The Grumbachers left Key West for their home in York, Pennsylvania, but three days later, Nancy called Baer. She could not forget the wonderful feeling she had when she first walked through the gate leading to the house on South Street. "The vegetation is so fabulous," she says of the grounds. "When we walked up onto the porch, I could almost sense the house literally calling to us."

Once the Grumbachers purchased the property, Baer set to work doing that magical thing he does with every house he decorates. He changed all the lighting fixtures and the colors of the rooms, using Benjamin Moore Philadelphia Cream for the walls. With Baer's professional guidance, Nancy has achieved a perfect combination of comfort through properly scaled furniture and individuality with the selective placement of art and personal objects. The grandeur of the living room is immediately apparent, but the space is inviting. As Bear explains, "Each place I design has different requirements. Of course, I know Nancy and Tim so well and this house suits their lifestyle perfectly."

A winding brick path leads to the entryway of the wooden house surrounded by lush plantings.

149

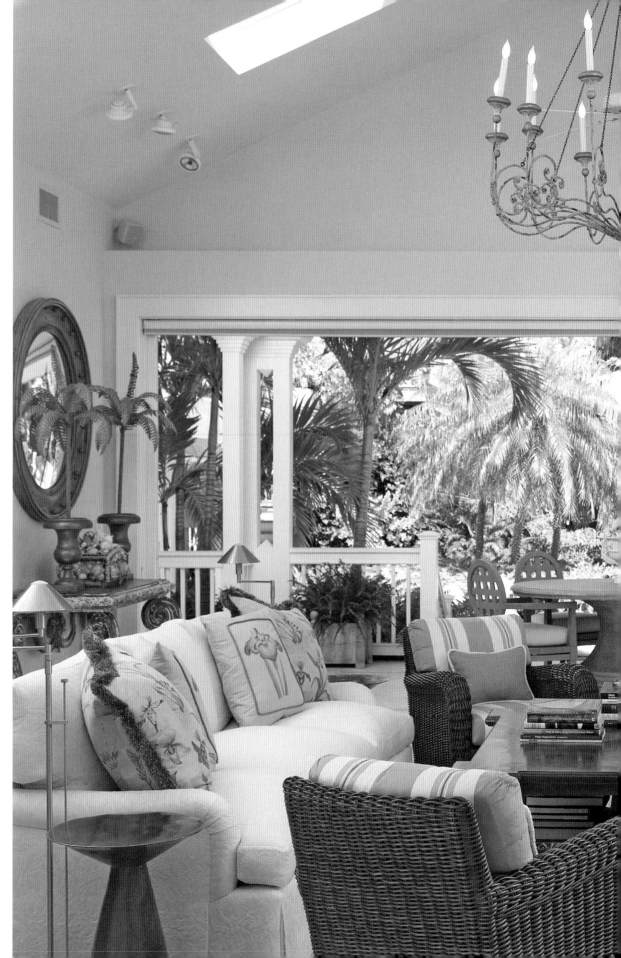

The back wall of the living
room opens completely
so that there is constant
flow from inside to out.
The tones of the plantings
are reflected in the
interior design. The room
is furnished with large-
scale Donghia wicker
furniture, and the
chandelier is by
Niermann Weeks.

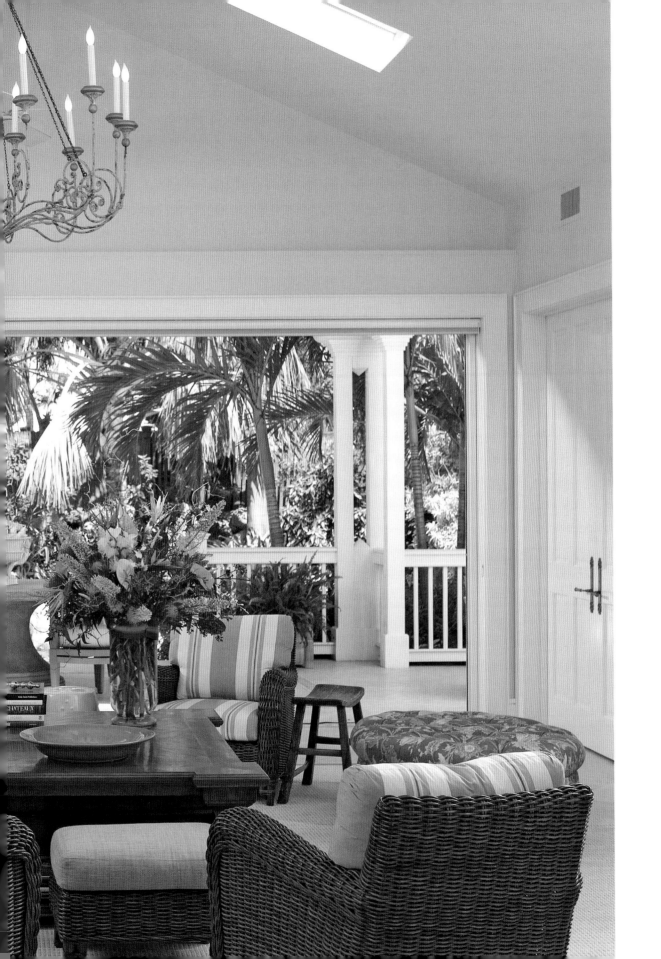

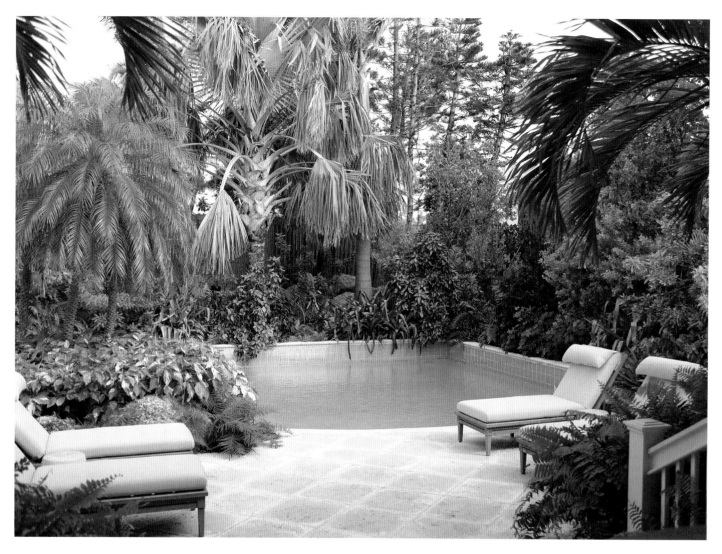

The pool is surrounded by mature tropical plantings for total privacy.

The house is on a busy street, but the high fence and lush plantings protect their privacy. Most of their time is spent in back on the spacious deck and patio around the pool, from which the view of the tropical plantings is nothing less than spectacular. "This house gives us a feeling of freedom. "Nancy says. "I love to entertain and have guests, but I enjoy my alone time when I can be by the pool with no particular agenda."

Among her visitors are her children and grandchildren. "This is a real family house that everyone enjoys," she continues. "There's plenty of privacy even when the whole family is here and it's an easy house to maintain, with everything on one floor." The two guest bedrooms, each

A library table stands against the wall in the foyer. The shell-encrusted stone basket is by California artist Susan Kizer. The runner is an Art Nouveau palm leaf design.

The wide front porch is furnished with a rattan seating arrangement. Bahamian louvered shutters adjust to control the lighting and airflow and are painted the same soft green as the underside of the roof.

Stone gourds become interesting sculptures on the table. The richly colored fabric is soft and welcoming on the porch furniture.

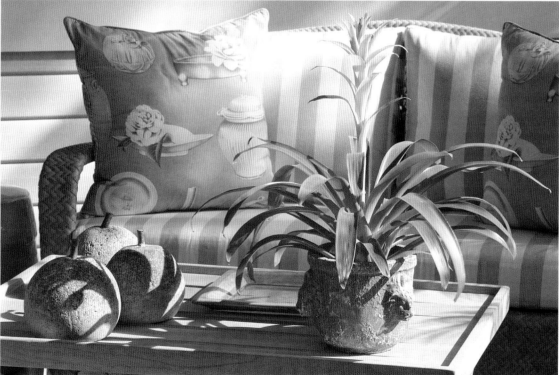

The kitchen, with tiger
maple cabinets, is open
to the living room. French
mixing bowls on the
counter are always filled
with fruit.

A fish-eye mirror hangs over
a seventeenth-century
Italian sideboard at one
end of the living room.
The shell box is the
perfect accessory
between two topiary
trees in matching urns.

with a private bath, open into the front hallway, and the master bedroom and bath are just off the living room. All three bedrooms open onto a side porch where one can take a quiet break, if desired. The Grumbachers' son prefers the guest room over the garage. "He loves to stay there and says it feels like being in a tree house," Nancy says.

After four years, the Grumbachers are completely settled into Key West living and consider the house finished. Tim and Nancy collect art and antiques and buy for their houses when they travel. They are passionate about outsider art and have several paintings by Thornton Dial and Jon Serl, whose works have been featured in many gallery and museum shows. Their collection also includes other artists who create outside the mainstream and produce works of outstanding originality in concept, subject, and often technique. These paintings are the personification of the Key West spirit that both Tim and Nancy embrace.

A Modern Interpretation

This sleekly modern concrete house in the Casa Marina area of the island was built in the 1950s and remodeled in the 1970s. In 1999 the current owner hired local architect Tom Pope. He designed an addition that meshed "the outside and inside by using the most amount of glass possible but still making the house hurricane proof" and also created the landscaping, which includes a pool and a pool house with a sitting room and bath.

This homeowner first came to Key West for a vacation in the 1980s. While staying at the Gardens Hotel, he began looking for the right property to buy. The houses in this area, near the Casa Marina Hotel, have more land than those in Old Town, and both the location and the double lot were appealing.

The interior design of the house might be described as minimal. "Someone told me that keeping the scheme monochromatic, using less color than one expects to find in Key West houses, would be soothing, and it turned out to be true," he says. "This house has a calming effect, and I feel at peace here." He adds, "When I was furnishing the house, I thought about each piece. I wanted it to be carefree living and good design at reasonable prices. Even if I were a billionaire, I'd still look for bargains. It gives me great pleasure to find a deal."

The interior layout comprises an open living room, dining area, and kitchen with a bedroom and bath off each side of the main living space. A circular stairway leads to a balcony loft into which a compact office and storage area have been tucked. A niche above the living room holds an arrangement of artifacts from Africa, New Zealand, and New Guinea. The house's bold right angles are softened by the subtle curves of the sofas and metal staircase. Paintings and rugs add just the right texture and color to the room.

The soft curves of the furniture and stairway in the living room counterbalance the sharp right angles of the contemporary structure. The ceiling height varies to create a dramatic double-height space.

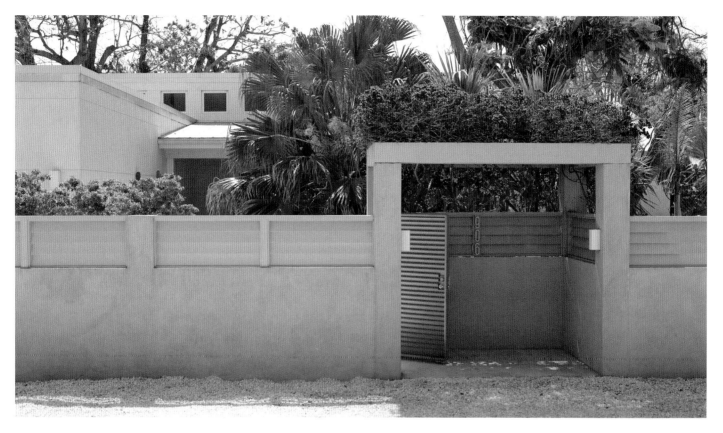

A solid gray wall along the street is high enough for privacy but low enough for a glimpse of the sleek lines of this contemporary house. The entryway is covered with pink bougainvillea.

"I become an amateur artist when I'm here," the owner says about the painting that hangs prominently in the pool house. "There's another one over my bed."

An admitted physical fitness nut and bicycle enthusiast, the owner stores his bikes in the garage at the side of the house, a rare commodity on the island. "I often ride around the island twice in a day, which is about 30 to 40 miles," he says.

A solid wall surrounds the property, and palm trees grow in the front, screening the one-and-a-half-story house from the street.

Bright pink bougainvillea grows over the entryway, and other exotic, tropical plantings dot the property. Black river stones, concrete paving blocks, wooden decking, and stone walkways complete the landscaping. It's like a micro-minipark with a Bismarck palm as the main attraction. Most of the living at this residence takes place in front of the house under the open-air roof. This area is furnished like a living room, arranged with a bamboo sofa and chairs and simple stone tables.

This island resident says living here is as close to paradise as he can imagine.

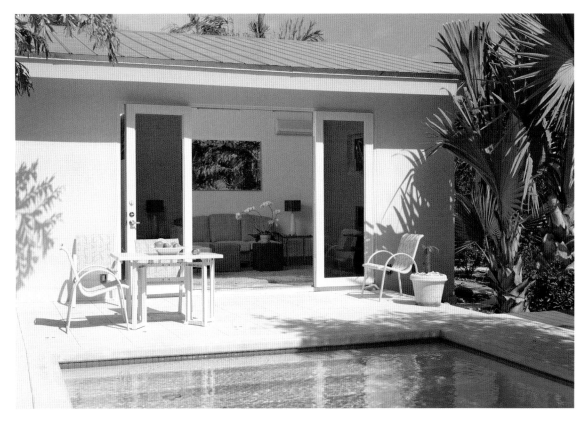

A painting by Richard Vincent hangs prominently over the sofa in the pool house. Outside a simple table and chairs provide an area for breakfast or drinks.

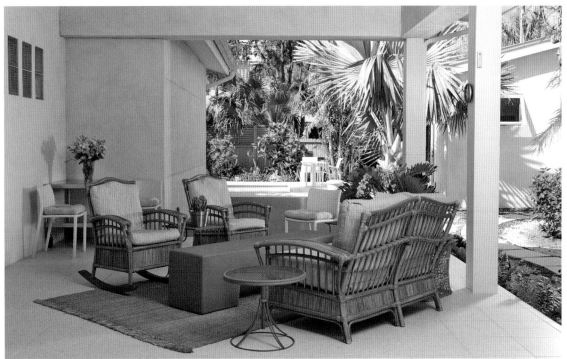

A roof turns this area between the house and the pool into an outdoor living room. Bamboo and stone furnishings extend the monochromatic color scheme used inside.

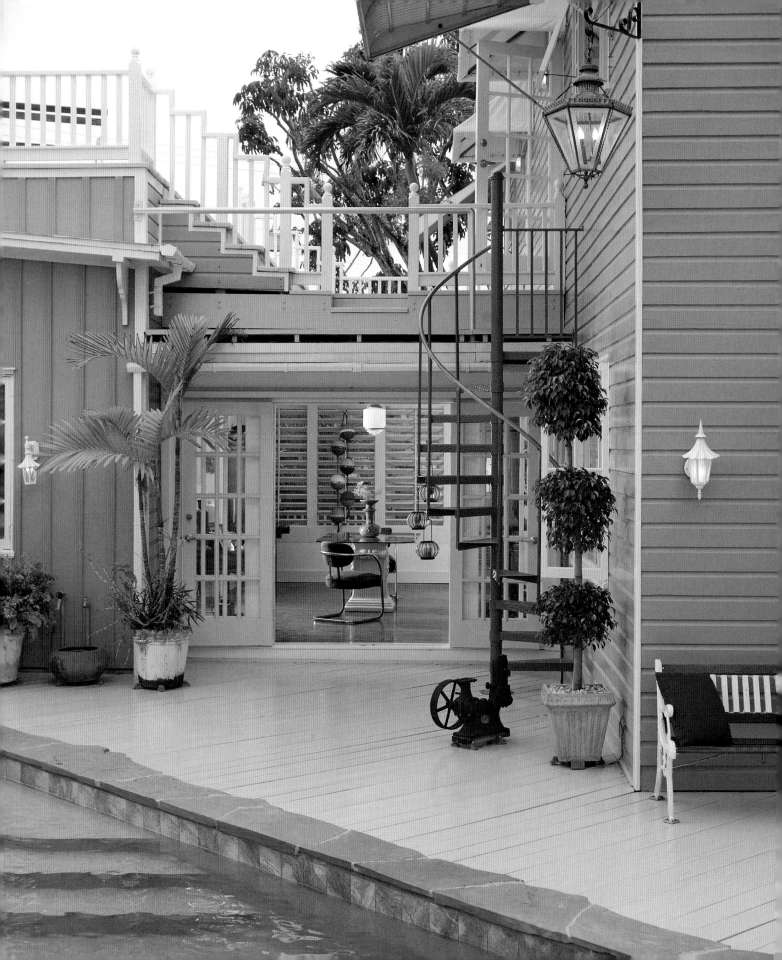

A House with a Past

Twenty years ago, Kenny Weschler came to Key West for a short visit, and like so many who had come before him, he ended up staying. "I went looking for my dream house," he says. "I wanted a little getaway in the most beautiful, charming, and wonderful place I had ever seen." What he found was a former military barracks that had been moved to this fashionable part of town in 1940 and converted into a home. But this is not the most notable part of the house's story.

The two-story house on Von Phister Street was once owned by the playwright Tennessee Williams. Williams, who also owned a house on Duncan Street in Old Town, bought the place for his sister, Rose, who was the model for the shy, lame Laura in *The Glass Menagerie*. Although year-round resident Weschler has lived here since 1987, people still refer to this house as the "Rose Williams house." Tennessee threw many of his legendary parties here. "As a result, the townspeople know and feel a historic familiarity with this property," Weschler says. To keep this bit of Key West history alive, Weschler has left Rose's room intact, with all sorts of Williams memorabilia gracing the walls and tables, in a small but fascinating museum-like display. Weschler also opens his house for fund-raising events, most recently, "Equality Florida." He says, "This community is unbelievably generous, and the house has proved to be great for large gatherings."

There is a large front lawn, a good-sized deck, and a pool bigger than most found on the island. Party guests often gather to watch the sunset in an upper pavilion, which is accessible via an outdoor spiral staircase.

No substantial alterations have been made to the house since 1953, when an addition was built at the rear. Even the original Dade County pine walls have never been touched.

A dining area opens to the patio and pool, and a circular stairway leads to the upper deck pavilion.

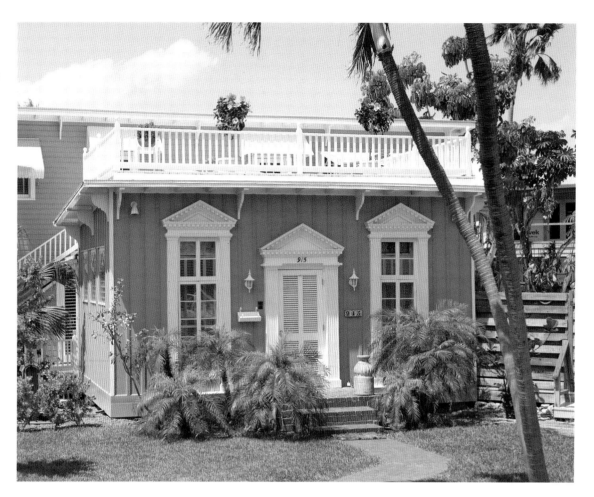

But Weschler is an appreciator of art, especially from the 1930s, 40s, and 50s, and in this way he has added his own touch to his home. Included in his eclectic collection is a rare watercolor by Alexander Calder, an Andy Warhol print of Tennessee Williams, and paintings by Robert Franke and Keith Bland. Also among his paintings are works by local artists Rick Worth, Susan Sugar, Michael Palmer, and Sal Salinero. He says, "I love collecting art, and I'm always adding and subtracting and changing things around."

When Weschler arrived in Key West, he brought with him years of experience as a landscape designer, designing penthouse rooftops and backyards of Manhattan town-houses. Kenny became the man responsible for keeping many of the gardens and much of the landscaping in some of the most exquisite homes in Key West looking as good as they do.

"Gardening is my passion," he says. "My satisfaction is in keeping these gardens frozen in time. Here in the tropics, everything

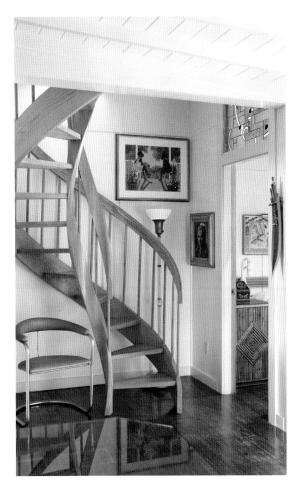

grows like crazy. It's my job to keep the essence of the grounds intact. In a way, the garden is the most important room in the house, because everyone lives outdoors, or the surroundings are part of the interior designs." About his own house he says, "The vibes in this house are supposed to be treasured. I really believe that, and it should be passed on to someone who shares the passion and cares about the good old times on the island of Key West."

NEW TOWN

In a loose way, White Street and an extension of Von Phister create the
dividing line between the Old Historic District and New Town. Once a
commercial area with cigar manufacturing plants that employed as many
as 600 workers in one factory alone, New Town is now more residential
than commercial. In the 1800s the four-story Havana-American Cigar
Company was located on Third Street and many of the workers lived
within walking distance of the factory. The houses in New Town, which
is farther away from the town hub, are primarily built of concrete block
rather than wood. Like those in Casa Marina they tend to have more
property around them than those in Old Town.

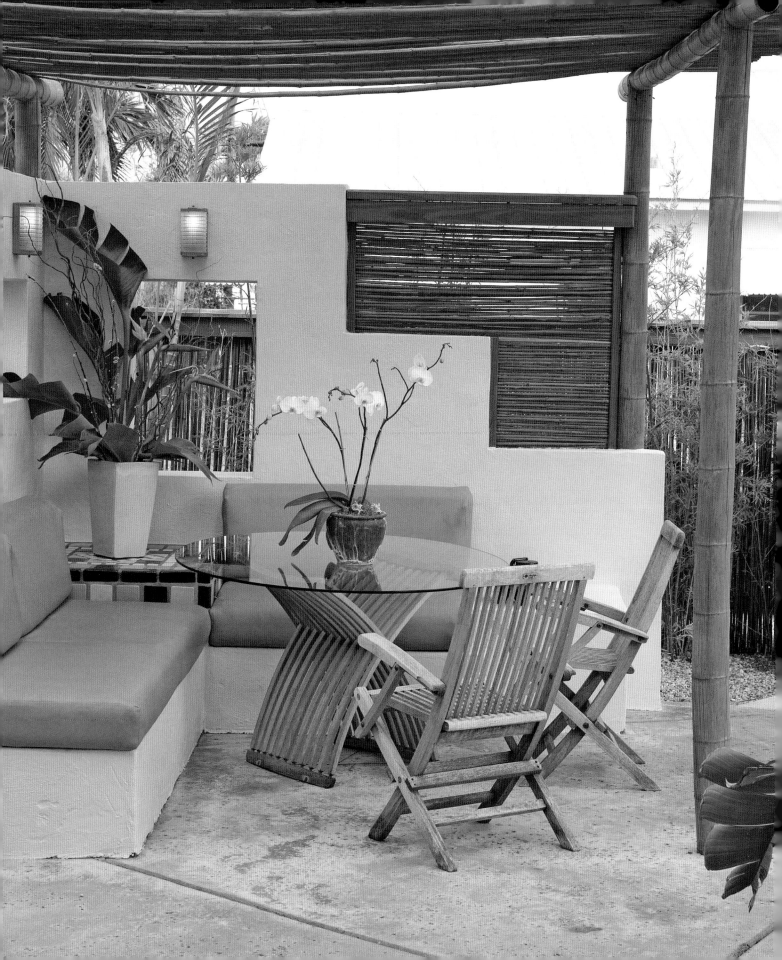

Midcentury Modern

Many of the houses on the outskirts of town were built in the 1950s, and
these concrete-block structures have great potential to be renovated in
a contemporary style.

Guillermo Orozco and his partner, Kent Ducote, did just that. According to a
recent article in the design magazine *Inside Out,* Orozco is one of the rising stars on the
architectural scene in Florida, and he has received ten awards for his designs from the
Historic Florida Keys Foundation. Orozco is originally from Colombia, South America,
where he earned a degree in architecture, but he and Ducote arrived via New Orleans.
"We came for a visit," Orozco explains, "and we never left." A residential designer
specializing in historic preservation, Orozco received a master's degree from Tulane
University in Louisiana. He worked in three different architectural firms in Key West
before going out on his own in 1994. It was then that he and Ducote went looking for
a house to buy.

The one-story house Orozco and Ducote found on the corner of Seidenberg and
Third Street was typical 1950s construction with small rooms, no charm, and a tiny, dark
kitchen. Because Orozco has designed many renovations and additions for existing houses
in Key West, he was confident about his approach to his own project. "We knew we wanted
modernism, and when we saw this house, we recognized its basic good lines and I knew
I could capitalize on what was there without changing too much. The layout was basically
good, and I worked with it, opening it up to allow light into the rooms. I knew I could
make it into something that would suit our lifestyle."

The addition Orozco designed includes a master bedroom and bath and looks as
though it is original to the house. "We loved the entrance to the house, and I knew right
away that a second floor over just that area would be architecturally exciting." But Orozco

A small pavilion at
the back of Orozco
and Ducote's house is
an extension of the
interior living space
—and a pleasant spot
for breakfast.

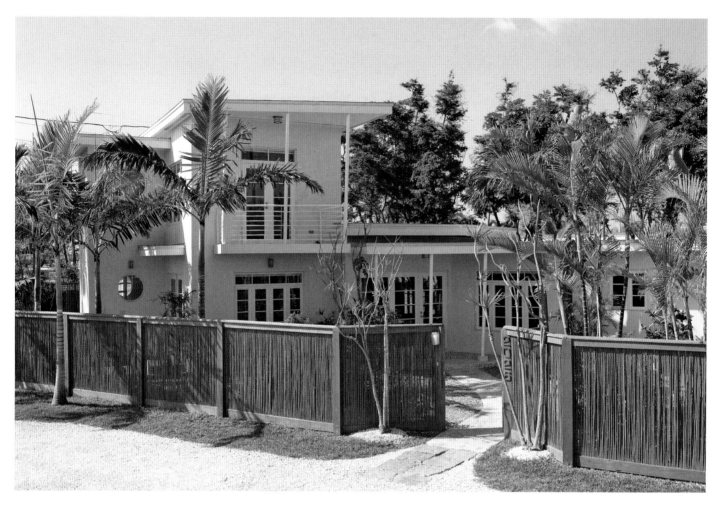

emphasizes that the most important aspect of the project was "preserving the postwar modernism of this midcentury, midtown gem. Features such as terrazzo floors and casement windows, as well as the furnishings, reflect the period and spirit of the house."

There is a lot of living space packed into 1,350 square feet. The first floor includes a living room, dining area ("We like intimate dinners with just two other friends, or never more than six at the table," Ducote says), streamlined kitchen, sitting/guest room on what had been a porch, and two offices on the main floor, plus a bathroom that was left intact with 1950s tile. Ducote, a business consultant, works out of an office that opens onto a small, private garden area. Orozco's office is larger, and evidence of his current projects takes over the expanse of workspace around the glass-enclosed room. "Working at home allows us to integrate

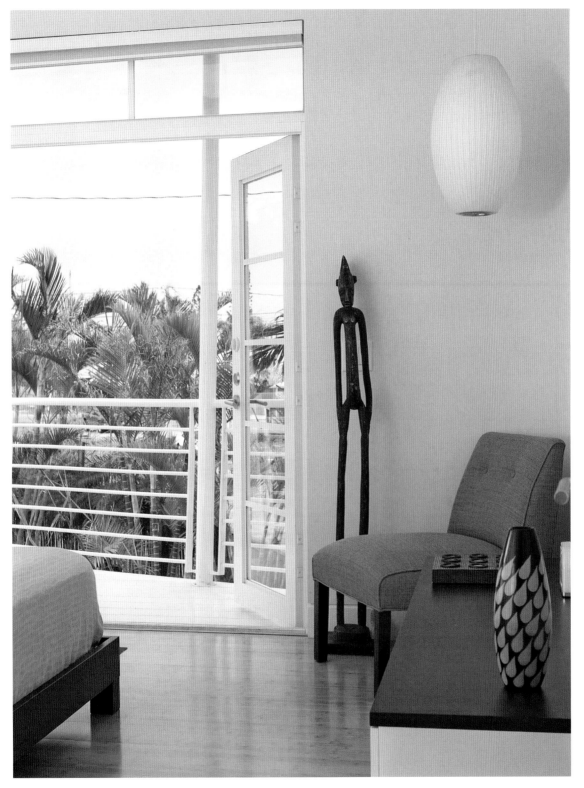

The upstairs bedroom
opens to a narrow
pie-shaped balcony
overlooking the pool.
The furnishings are spare,
muted, and calming.

171

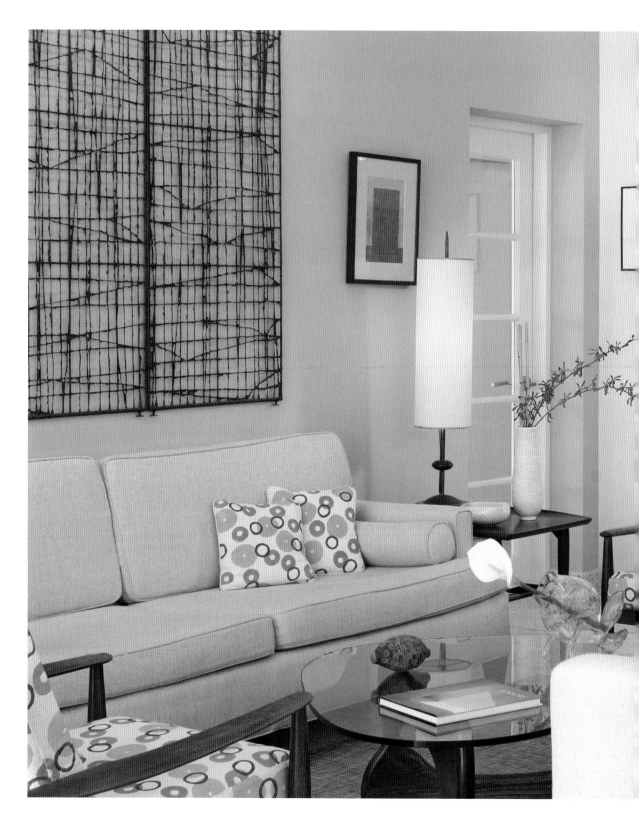

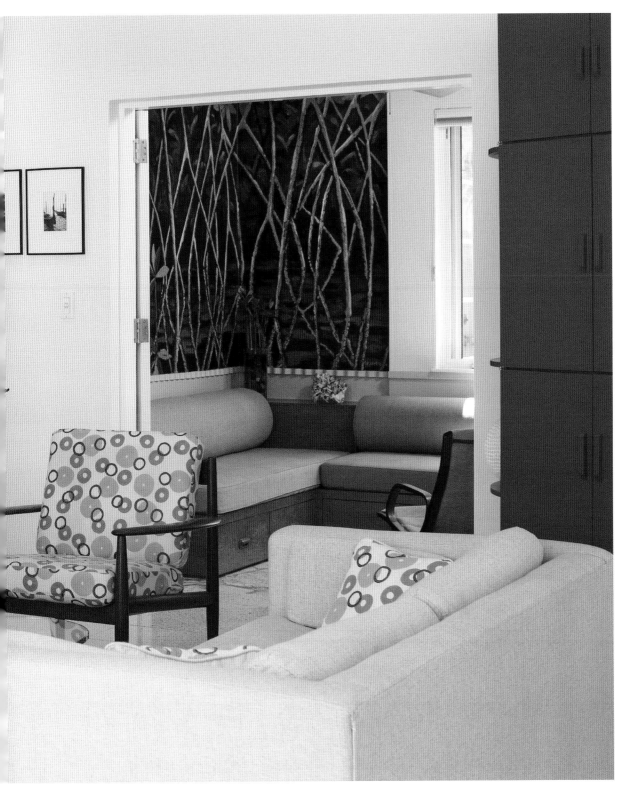

Danish Modern furniture of the 1940s and 1950s stands the test of time in the living room. The screen over the sofa is from Indonesia. A small porch off the living room was converted into a guest room. Local artist Rick Worth painted the mural.

work and living," Ducote says. "We can be more creative and productive when we can take breaks now and then to do things around the house."

The simplicity of Danish Modern furniture, austere and functional but refined and elegant, is perfect for this house. Decidedly sculptural in design, original Danish Modern furniture helped define the 1940s and 1950s. "We found most of the pieces at yard sales, secondhand shops, online, or at flea markets and mixed them with 1950s contemporary," Orozco says. Danish Modern furniture was made of teak, rosewood, cane, and wicker, and the fabric on upholstered pieces was always one hundred percent wool.

Orozco says, "I love color, but serenity works better for us at this point in our lives. Neutral, off-white, earthy tones are easy to live with when your life is hectic." Black–and–white photographs, as well as paintings by local artists such as Roberta Marks, are placed to become part of the whole.

The size of the kitchen remains the same, but the room is now streamlined, contemporary, and functional. It is also bright. "What was missing from this house was the relationship to the outdoors, so we removed a single back door and replaced it with a double glass door to make the outdoors part of the house," Orozco points out.

This doorway leads to an enchanting pavilion, his interpretation of what is usually defined as "a sort of ornamental building, lightly constructed, often used as a pleasure house or summer house in a garden."

"Bamboo is a favorite material of mine," Orozco says. "Bamboo is used extensively for building in Colombia, where I grew up. I use it a lot in my work because it is strong as steel." He adds, "Not one stick in my fence flew out during Hurricane Katrina, which hurt this part of the island. It grows like weeds and it's pretty." The built-in concrete banquettes are softened with cushions covered in weather-resistant marine material the same color, celadon, found on accent pillows in the living room. Ducote and Orozco call this oasis "Kentina del Sol."

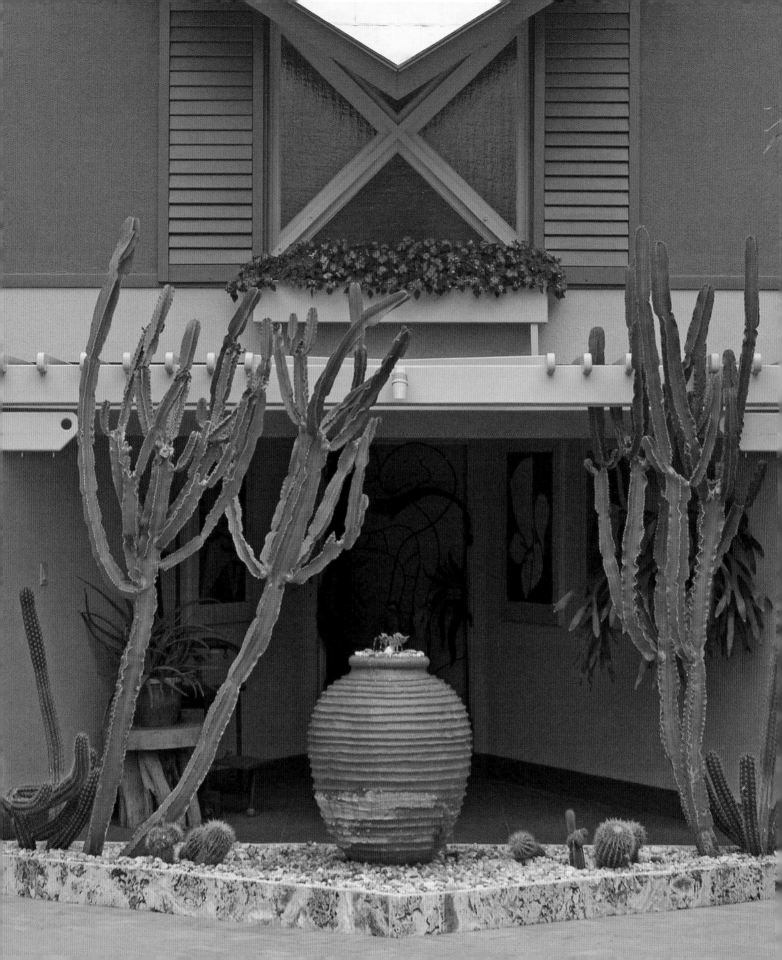

A Colorful Invention

In New Town, where building regulations are less stringent than in the historic district, one finds some interesting and rather unusual structures. The area attracts those with a creative bent who might like to do what Woody and Joan Cornell did—build their own home in their own way.

Before coming to Key West in 1971, the Cornells owned a bed and breakfast in Vermont. But these days, they divide their time between Key West and their farmhouse in France. Together, Joan and Woody (more formally, Stephen Wood Cornell III) have built a home with personality, a testament to their fun-loving natures and discerning taste. It is at once quirky and whimsical, extremely personal, and practical for the way they live—a house that is unique, even on this island where uniqueness is de rigueur. No square inch of this house has been left to chance, and the couple has employed some great ideas to make the living easy here.

Their passion for nesting is evident in every room. One finds niches and hidden drawers, cubbies and storage, with special care taken to hide the not-so-pretty necessities of everyday life. "You'd never know it, but I'm a minimalist at heart," Joan says. "I throw away anything that we don't love or enjoy using, looking at, or living with. We're constantly weeding out so we can add some new acquisition." They love collecting art, and local art and sculptures mix easily with pieces acquired on travels around the world. This house is also a tribute to Woody's ingenuity. An inveterate inventor, Woody engineered and built the house with his own hands. His father owned a lumberyard where, as a boy, Woody cut his teeth, so to speak.

When not tinkering and perfecting their domain, Woody volunteers as the tour coordinator for the popular Old Island Restoration Foundation House and Garden Tours, which raises funds for the preservation of the architecture and heritage of Key West and

Cactus and an adobe-style pot lend an unusual southwestern feeling to Woody and Joan Cornell's house.

for the operation of the Oldest House Museum and Gardens and the Mallory Square Museum. Joan is active in the Key West Art and Historical Society, which is responsible for maintaining the Custom House, Lighthouse, and East Martello Tower, historic buildings open to the public. She is also helping out with the newly created antiques show at East Martello Tower, initiated by folk art dealers George Korn and Richard Kemble. "We are nurtured by this community," Joan says, "and we derive great pleasure from giving back."

Although the Cornells' house sits on a double lot, it is not large. The real extravagance, by Key West standards, is the two-car garage. There are few garages in Key West, and the Cornells make good use of the space, storing much more than Woody's bright yellow truck. The landscaping is almost Southwestern in appearance, with cacti growing through pebbles and a large adobe vessel out front. There is never a missed opportunity, either inside or out, to display artwork both serious and lighthearted. Take, for example, the chair in the entryway that

looks like a prototype for a strange new invention, or the spider-leg sculpture quite at home in the meticulous border garden surrounding the curved driveway.

The tiled foyer on the street level is a first-time visitor's clue to what lies ahead. A carefully arranged assortment of artifacts, from a statue of a tuxedo-clad rooster holding a plate of fried eggs to the model train and ornate clock above it, sets the stage for the main event.

The house is organized vertically, with rooms on four levels, and the second level is the living space. The open floor plan includes a kitchen, dining area, and cozy living room. A large stained-glass window in the dining area breaks up the glass expanse of the doors that lead to the patio and pool. Like most kitchens in Key West, theirs is small. But Joan points out a particularly interesting feature: "If you notice, the faucet and handles are hidden. Woody is a genius at doing things like that." Overhead is a painting. "We fell in love with that painting but didn't have a place to hang it, so we put it on the ceiling," Joan explains. After being in their

The kitchen, dining area, and living room together form one open space on the second level. Tractor seats pull out from the kitchen island.

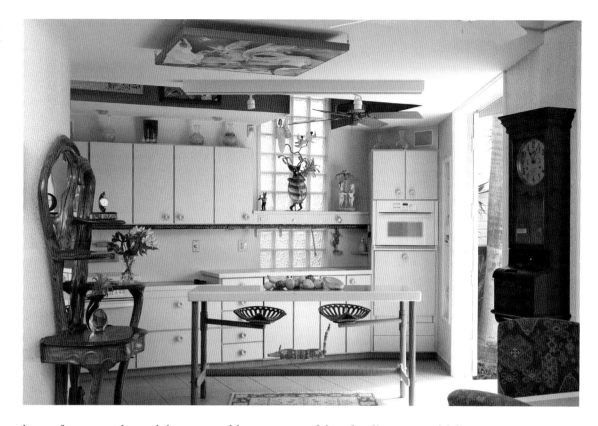

house for even a short while, one would expect this sort of solution from the Cornells. Bright pink tractor seats tuck away under the kitchen counter when not in use and become part of the artwork, silhouetted against the white cabinets. A group of carved wooden musicians from Mexico are displayed, and over the sink, another whimsical figure from New Orleans.

Up a few stairs are two bedrooms and bath. On the landing more art abounds. Like visiting a museum for the first time, it is too much to absorb in one visit. Almost every known Key West artist is represented throughout the house: Michael Palmer, Rick Worth, and one

of the island's treasured folk artists, Jack Baron.

A wood ceiling curves over the top floor like an upside-down ship, punctuated by ceiling skylights through which sunlight streams into an office space. Tucked up in the treetops, this is a wonderfully private room for taking care of paperwork or simply relaxing above it all.

Joan describes what she likes best about the house: "Even though it's on four levels, it's quite easy to maintain. And it's always light and bright and cool. We never use air-conditioning, because of the placement of windows for cross ventilation." And since Key West is an island, there is always a breeze.

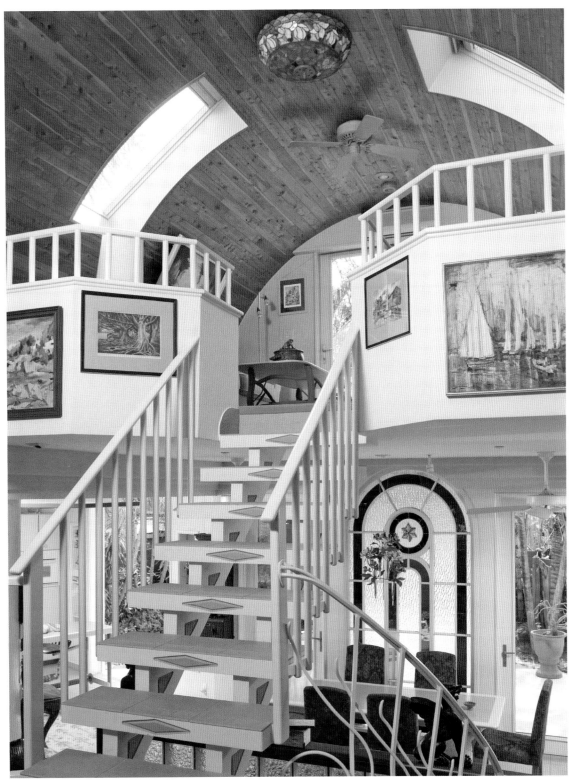

LANES, ALLEYS & BYWAYS

All over Old Town one finds, if one is looking, a lane or alley that looks like a driveway. They are easy to overlook as they crop up in the middle of main streets like Fleming or William. Sometimes the lane is marked, sometimes not. Sometimes there is only a house or two on a ten-foot wide lane, other times there might be half a dozen houses on a lane. When you discover a lane you're sure it has been undiscovered until that very moment and each stroll down a newly found lane or byway is nothing less than a surprise. The houses on the lanes are charming. Some are shotguns with no property at all. Others might have been enlarged and reconfigured with rather sprawling grounds, by Key West standards. I have never been down a lane or alleyway that didn't make me want to return again and again.

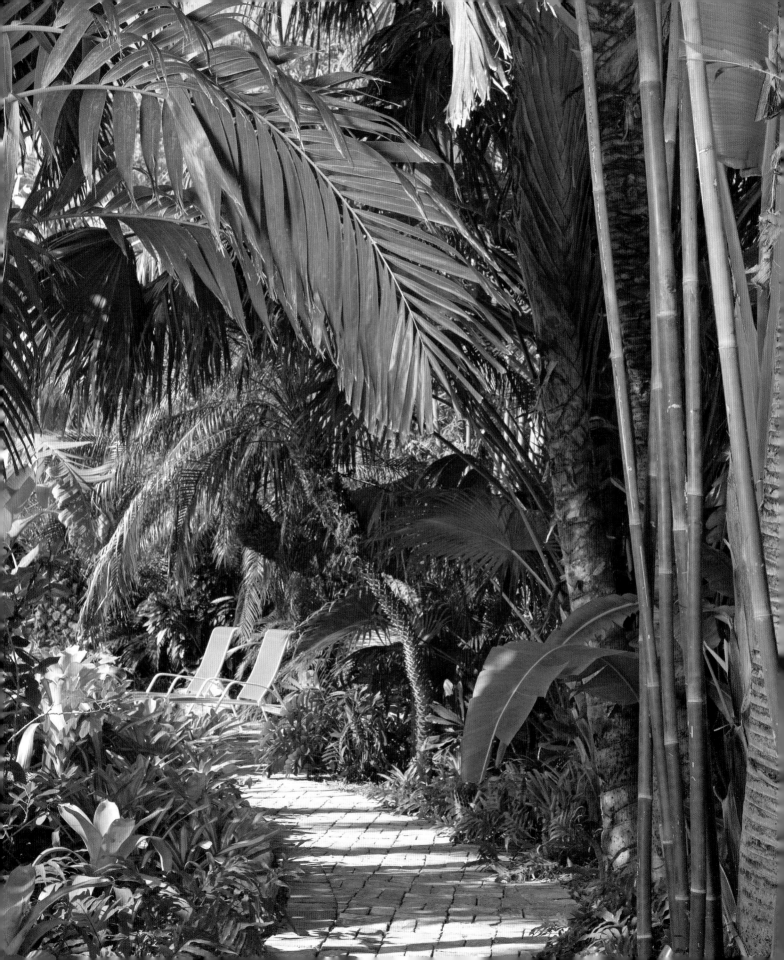

Down Schippens Lane

"Where is Schippens Lane?" even a longtime Key West resident might ask. Like most of the lanes in Old Town, Schippens Lane can be mistaken for an alley or a driveway. One might have unknowingly passed it hundreds of times when bicycling or driving down busy Fleming Street. It is not even listed in J. Wills Burke's *The Streets of Key West: A History through Street Names*. Nonetheless, it exists, and once one finds it and meanders all the way down, it is not easily forgotten.

When Margo and Bob Alexander first came to Key West, they rented a house on Love Lane, so it was not without a feeling of "lane envy" that they went looking for their own little piece of paradise. They bought their house on Schippens Lane in 2001 and lived in it as it was. "Like so many houses in Old Town, it was in need of renovation and the property was overgrown and out of control," Margo says. "There were lots of little rooms, but we wanted to live in it before deciding what to do first. We consulted with local architect Guillermo Orozco and felt confident that together we could turn the house and property into an exciting and fun place to live."

Today, the property is entered through a trellised portico, and it is a jewel among jewels. A brick path leads from the front gate and winds along the edge of the grounds and around the pool. The tranquil ambience is pervasive, and the soothing sound of water from the fountain is positively musical. Human sounds almost interfere with the quiet nature of the place. The property is large by Key West standards, especially for a lane, and the house is set to one side, with the landscaping and pool in the front. The grounds are enclosed with a fence and mature palm trees and bamboo. Margo says, "Pat Tierney

A brick path edged with palm trees and tall bamboo shoots winds along the edge of the lot. Landscape architect Patrick Tierney created the outdoor environment from the plantings that were taking over the property.

The newly added porch may be used for year-round living. Heywood-Wakefield bamboo furniture sits on a straw rug. One of Margo's vintage sand pails holds an orchid plant.

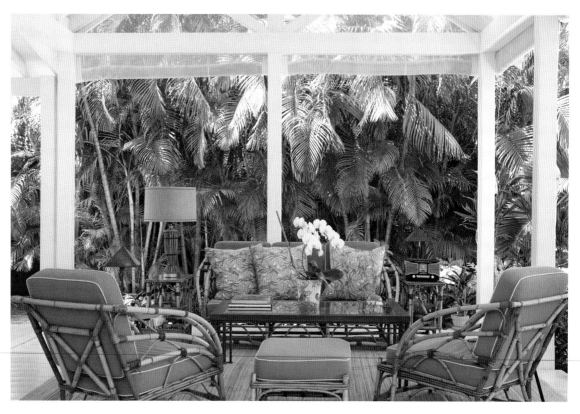

A covered portico leads off Schippens Lane to the Alexanders' house. The property is surrounded by a picket fence and tall palm trees.

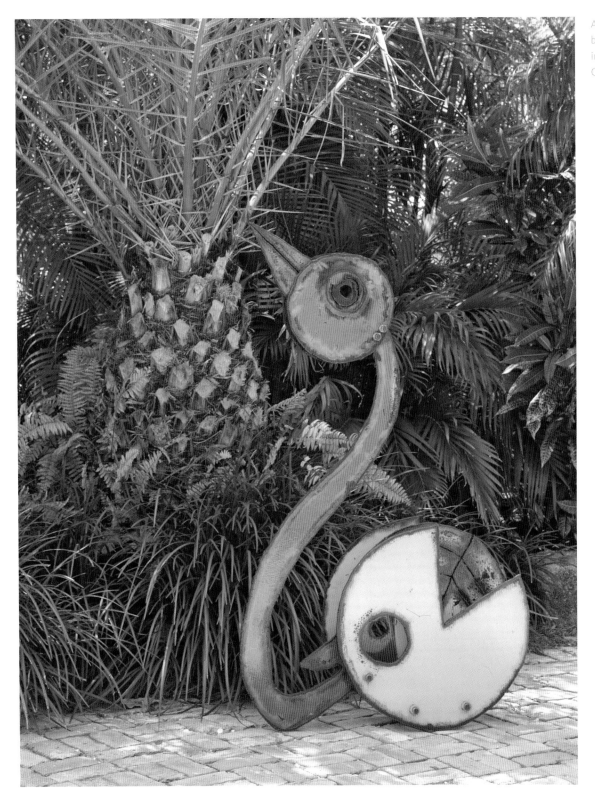

A garden sculpture
by John Martini poses
in front of a mature
Canary Island date palm.

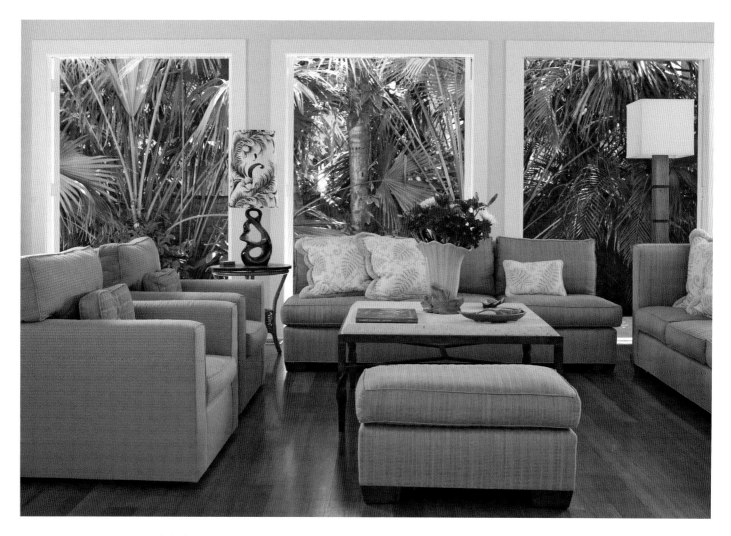

The new living room, which is more formal than the rest of the house, was decorated by Zinta Glazebrook. Heartwood pine floors and soft green fabric extend the feeling of the outdoors. An Art Nouveau vase by Sascha Brastoff is just one of the many collectibles that Margo has discovered.

did all the landscaping. He removed, reworked, and replanted." Also among the foliage are a lovely papaya tree and a mature Canary Island date palm.

"We gutted the house, and Guillermo designed the addition of the porch and living room. I love the openness of the house and being surrounded by plants," she says. "I worked with Zinta Glazebrook, an interior designer from East Hampton, New York. We weren't after any specific look. I just wanted to use things I love, local crafts, some eclectic pieces, and vintage fabrics. This house is my art project, and it gives me enormous pleasure." She continues, "Victoria Lesser, a former Key West designer, helped with the final details. We had a lot of fun, and I continue to perfect and move things around, adding here and there."

A narrow porch provides a private oasis off the guest bedroom.

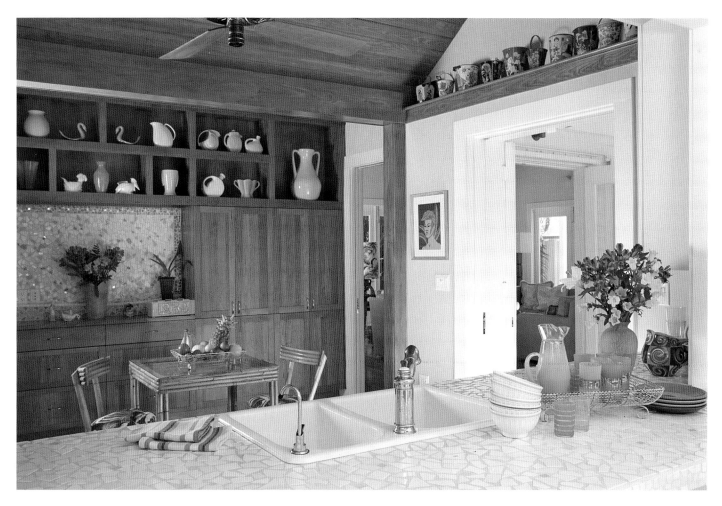

The Alexanders share an office in what was the original living room. As part of the renovation, the height of the ceiling was raised. From there, a stairway leads to a loft area over the bedrooms below and at the back of the house. Each bedroom has its own bath and opens onto a deck.

Margo says, "I have fun with this house. I collect little ceramic ducks and vintage sand pails and all sorts of other things that I buy on eBay. In a million years I wouldn't put these 'kitschy' things in my home anywhere but here." She goes on to say that Key West brings out the child in a person, and she can "play house" without feeling intimidated. "I buy what I like. For example, this mirror," she says, pointing out a sea-glass creation from a local gallery.

After many years in business, Margo uses her background for charitable activities. "Bob isn't here as much as I am," she says.

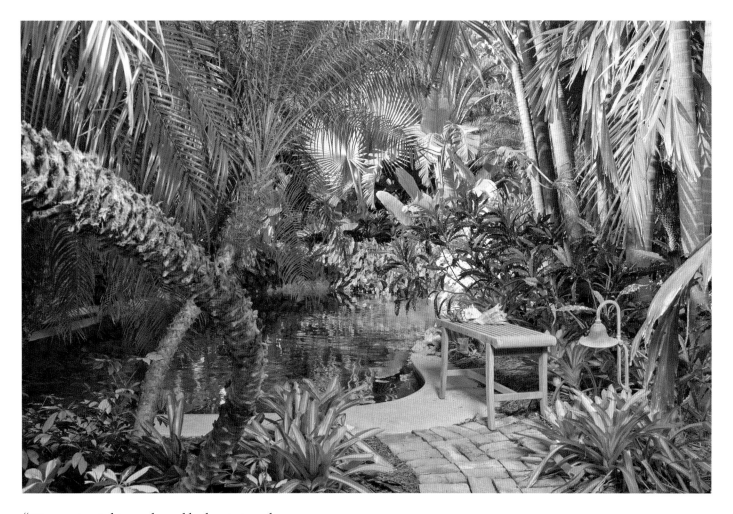

"His passion is his work, and he has to travel a lot." Even though Bob comes and goes, he gets into the slow pace of Key West the minute he arrives. The Alexanders do not have a car in Key West. Instead, they bike everywhere, and Oliver, Margo's dog, often rides in Margo's bicycle basket. "Working from this office overlooking the beautiful gardens and being able to walk or bike anywhere is as close to heaven as one can get," she says.

The gracefully shaped pool is set into the landscaping, almost like a secret lagoon.

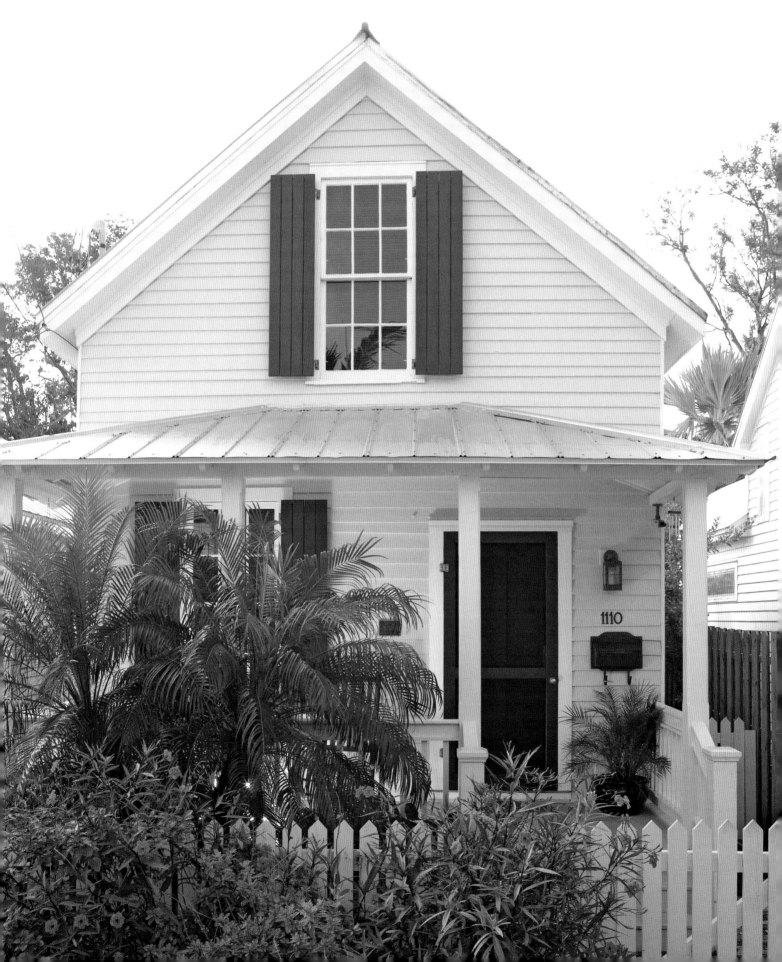

On Curry Lane

A shotgun house is a small wood-frame structure, usually a single room in width, with the roof ridge always perpendicular to the street. Often less than a thousand square feet, these structures are found throughout Old Town and were built in the late 1800s to house the growing population of cigar workers arriving from Cuba when the industry moved to Key West. Most explanations of the derivation of the term *shotgun* refer to the continuous passage through the house created by the alignment of front, back, and interior doors, which would allow a bullet to pass through without hitting an interior wall. Typically, the interior doors are located on one side of the hallway, with the rooms lined up one after the other and all opening into the hallway. The living room was in the front, followed by a bedroom, a bathroom, and, finally, a kitchen in the rear.

Shotgun houses are being gutted, added on to, and converted into contemporary cottages all over the island. They can be seen in clusters on main streets and down hidden lanes. John Dell and Barry Philipson live in a one-and-a-half-story converted shotgun on a long narrow lot on Curry Lane. Just as most streets in Old Town are named for the island's early settlers, so are the lanes. William Curry was a banker, merchant, and owner of wrecking schooners and the clipper ship *Stephen R. Mallory*. He died in 1896 with his reputation intact as the richest man in Florida. Many buildings in town bear his family name.

Dell and Philipson bought the house in 1994 but waited before renovating. "We had no air-conditioning for eight years," John said, "but we really didn't need it because the breeze blows right through the house." In 2005 the house received the coveted gold star by the Historic Florida Keys Foundation, and a plaque on the house deems it worthy

The one-and-a-half story wood shotgun house is located on Curry Lane in the heart of Old Town. Fire-resistant metal roofing is often used in tightly clustered areas such as this.

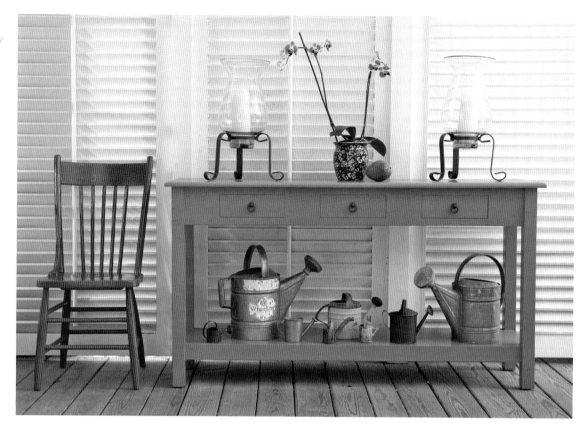

of a listing on the National Register of Historic Places. That same year, the owners hired local architect Guillermo Orozco to design the renovation and an addition.

"We didn't change the basic layout," John explained. A stairway to the right of the hallway runs from the front door to the back of the house, the walls still covered with the original Dade County pine. The small room in the front now functions as a sitting room. There are two bedrooms and a bath on the second floor, under the eaves. The renovation included the addition of a new living room with an open kitchen.

Glass doors open wide to the deck and pool beyond. "The house is comfortable and easy to care for," Dell says. Even with the addition, the house has not lost the charm of a small cottage. John says, "A big house is a waste. No one really needs a big house in Key West because you live outdoors all the time."

Philipson mentions that the two enjoy cooking and often entertain friends. He says, "Even though the kitchen is small, it is state of the art. We took great care designing the kitchen, and especially wanted the Vermont soapstone counters and sink. It's a softer material than marble."

The new galley kitchen, open to the new living room, has Vermont soapstone counters. Folk-art furniture, such as the cabinet with its original milk paint, lends character to the room.

The doors line up from the front to the back of the house. On the floor are a series of Oriental carpets, and on the walls is the original Dade County pine.

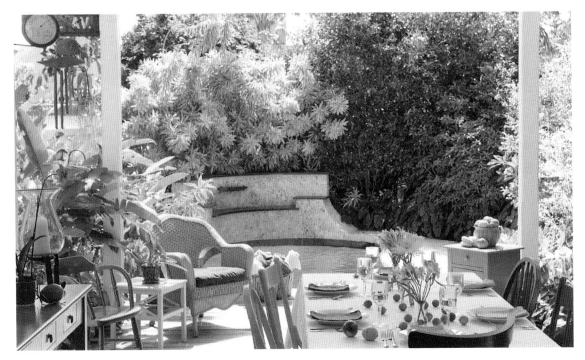

Dell and Philipson, who are in the local real estate business, hired island contractor Jordan Holtcamp for the construction and Rob Newman of Xanadu Gardens to design the landscaping. The Song of India, with its delicate leaves, hangs gracefully over the pool, flowering trees and shrubs such as the Jamaica caper create privacy, and the Burle Marx heliconia makes an interesting ground cover. Dell says they mix well with the philodendron around the property. For fragrance, Newman planted Simpson stoppers, a species native to South Florida, the Keys, and the Caribbean and a flowering and fruiting member of the myrtle family. This slow-growing, shrubby tree can grow to 10 feet in height, making it perfect for this environment.

The sculptural wall curving around the pool is set with sensuous river stones, one of Orozco's signature details.

An outdoor dining room was created under the roof overhang at the back of the house. The underside of the roof is painted blue, and Dell and Philipson also painted the furniture, all of which they found at yard sales. "We thought it would be fun to paint every piece a different tropical color. No two chairs are alike, but we think this is more interesting than a matched set."

These year-round residents love living in Key West and love their cottage on Curry Lane. Dell says, "It doesn't get any better than this. It's heaven with a fence around it."

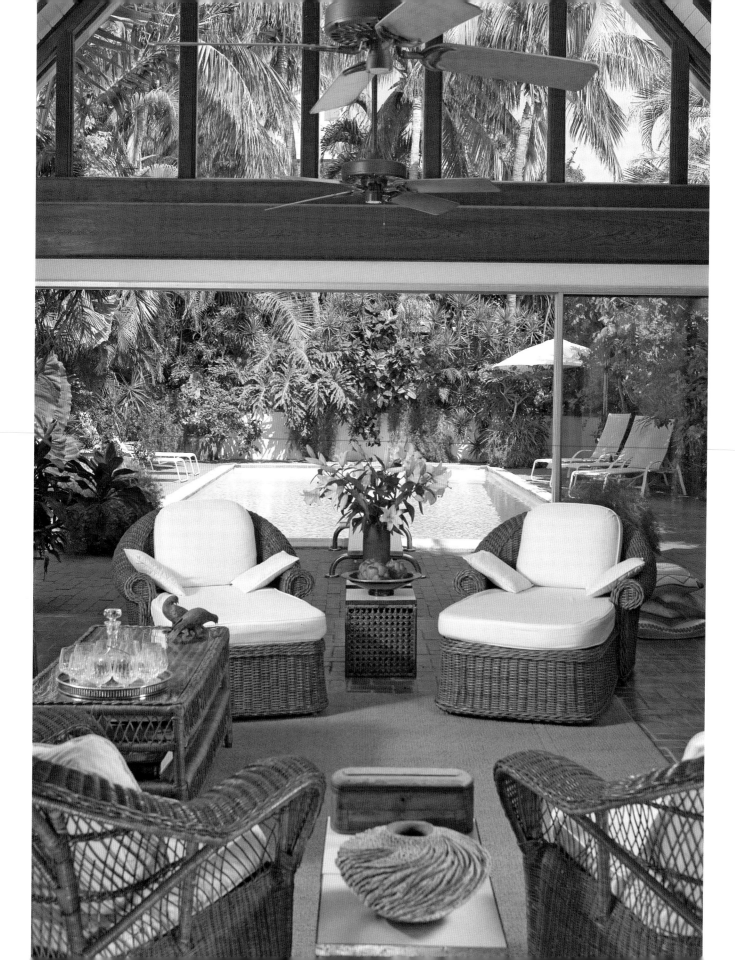

On Pinder Lane

In 1849 a rather small Conch house was built at the end of Pinder Lane. Pinder is a familiar name in Key West, and it is thought that the lane was named for William Pinder, who became a city councilman in 1911.

Today the house, owned by Bob Thixton and Dick Duane, who have lived here for over forty years, seems positively sprawling. "Of course it wasn't always this way," Duane says, referring to the renovation and addition that he designed. "We added the A-frame living room and the pool, and just two years ago we put in a new kitchen." Bob loves to cook, and they often have guests for dinner.

This quiet double lot spans the width of Pinder Lane at the front and spreads out to the back and sides. The property is ample enough to also include a delightful, two-bedroom guest cottage, which was built in 1873 and renovated several years ago. Thixton and Duane have successfully meshed the old and the new, retaining the charm of the original buildings but improving them for modern-day comfort.

The front door opens onto a brick-floor entryway, and to the right are the dining room and the stairway to the bedrooms on the second floor. One step down to the left and the magnificent living room with its vaulted ceiling opens expansively, making the gardens and Olympic-sized swimming pool part of the interior landscape.

When Duane mentions the gardens, Thixton interrupts. "Dick is a landscape genius. The trees and the tropical plants are beautiful from every window. Each time we come back it's a new experience and we are nourished. Even after forty years we are grateful all over again."

Art, sculpture, and memorabilia fill the house of these literary agents who have, over the years, represented and entertained many great stars. On the table is a photograph of Duane with Tallulah Bankhead, who gave him a bust of herself. Tennessee Williams and

The A-frame living room is comfortably furnished with natural wicker chairs, white cushions, sisal carpeting, and art, sculpture, memorabilia, and gifts from friends past and present.

The guest cottage has an open living/dining/kitchen area with the original Dade County pine on the walls. Five sets of French doors lead to a covered porch overlooking its own pool and garden.

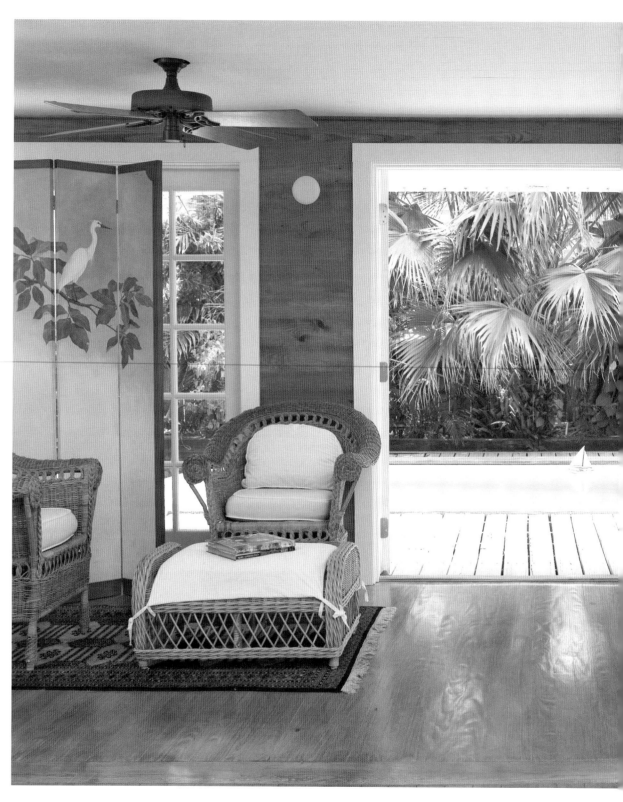

writer/actor James Herlihy were among the regular visitors. Resident Key West writers such as Richard Wilbur, William Wright, Alison Lurie, David Kaufelt, and next-door neighbor Nancy Friday are part of the mélange of colorful personalities who have and still do assemble here. On the grand piano in the living room, Leonard Bernstein and Peter Alan entertained equally well-known guests like singer Nina Simone and composer Alec Wilder. "There was always music," Duane says. This is a house filled with the good spirits of Key West in its heyday, when talented and intellectual people gathered for entertainment and stimulating conversation. And while the two owners do not entertain quite as much now as they used to, the ambience lingers.

Still, Thixton and Duane love it when the house is brimming with friends and family. Duane says, "People always drift in and out on Sundays, and now and then we have a large party." When they're in Key West, the guest cottage is usually occupied and island friends are constantly running in for a quick visit, without so much as a knock on the door. "This place is uncomplicated," Dick says. "Something magical happens here."

Duane and Thixton both agree that it is easy to work here—a wonderful place to read

The guest cottage, built about 1873 and on the National Register of Historic Places, is a shotgun house with a hallway running from the front door straight to the back.

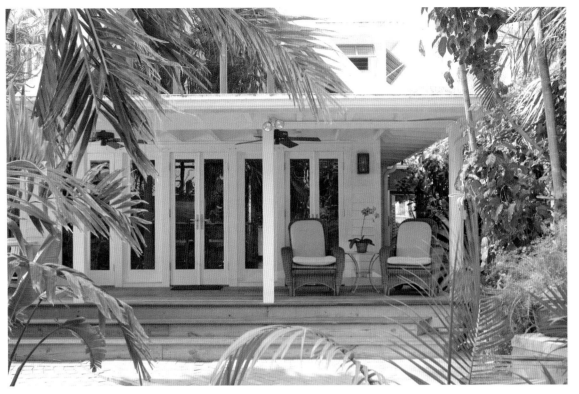

Dick and his neighbor, author Nancy Friday, find the secluded porch in back of the kitchen of the main house a perfect place for a tête-à-tête overlooking the gardens.

manuscripts and edit a book. Time slows down. But the feeling Thixton and Duane have created here is the stuff fiction is made of, and Key West provides the perfect backdrop for the lifestyle they have cultivated.

Dick Duane designed the landscape with its tropical plantings, brick walkways, and lion-head fountain.

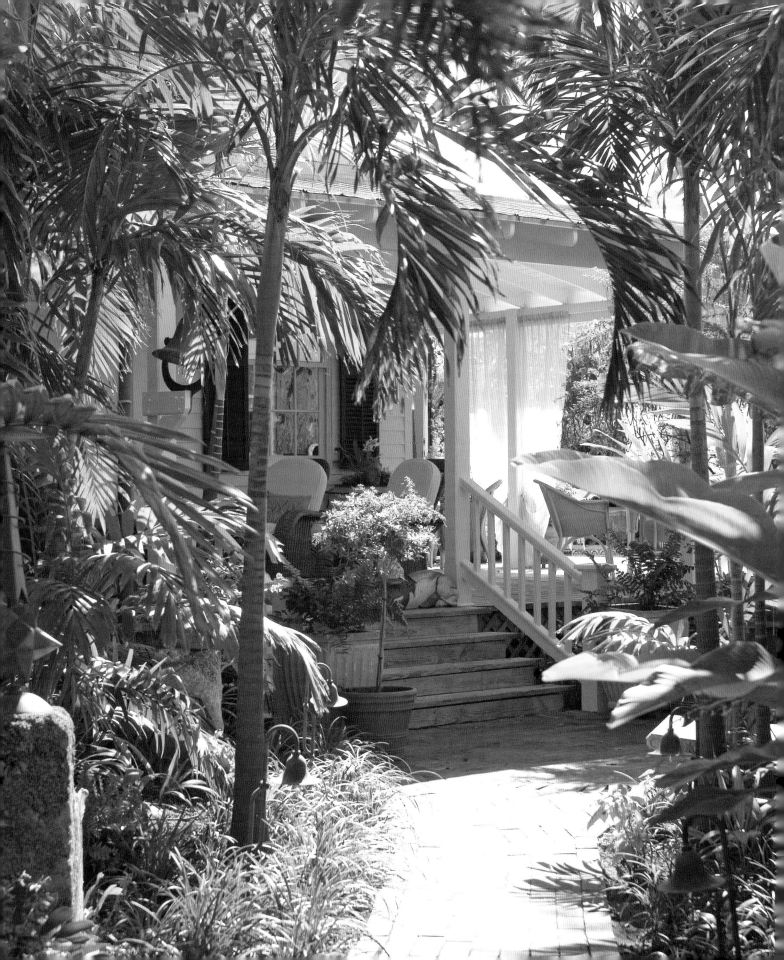

My Secret Garden

In 1992 literary agent Billy Barnes introduced his client best-selling author Nancy Friday to another of his clients, Tennessee Williams. Friday is from Charleston, South Carolina, and upon hearing this, Williams, who spent a lot of time in Key West, told her she had not gone far enough south. She took his advice and fell in love — with Key West, that is. "I loved the friendliness of the town," says Friday, who has written extensively on women's sexuality and whose books include *My Mother/My Self* and *Jealousy*.

When she first came to Key West, she stayed with her good friends literary agents Dick Duane and Bob Thixton, whom she visited often in New York. "I like owning property," she says, "and I knew I had to own a house here. My first house was on Southard Street. Actually, there were three houses on the property, just like I have here. I like the privacy," she adds. Friends stay in her guest house, and Kelley, who takes care of the property, lives in the other.

Nancy has what might be referred to as a compound, with the three houses surrounding what she's dubbed "my secret garden," named after one of her books. Kelley proudly points out various rare tropical plants and stone creations, as well as a variety of interesting pots and garden sculptures. It is an *Alice in Wonderland* experience. "Nancy finds things when she travels, and we've incorporated them into this garden. It keeps evolving," he says. "I never met a rock I didn't like, except gravel. I always do something new with them. I especially like the old foundation stones and coral," he adds. Brick paths wind in and out of the tropical gardens. Passion vine attracts butterflies, and hibiscus, yellow cassia, vermilliads, and bougainvillea intertwine. There is something new to discover around each bend. "I love the sense of place I have when I'm here," Friday says.

Friday's house is down Pinder Lane, but the entrance is hidden behind a gate and down a winding path laden with tropical plantings.

The living room is furnished with an eclectic mix of colorful artifacts from the owner's travels. Moroccan pillows, a Persian rug, and painted folk pieces mix easily with local art.

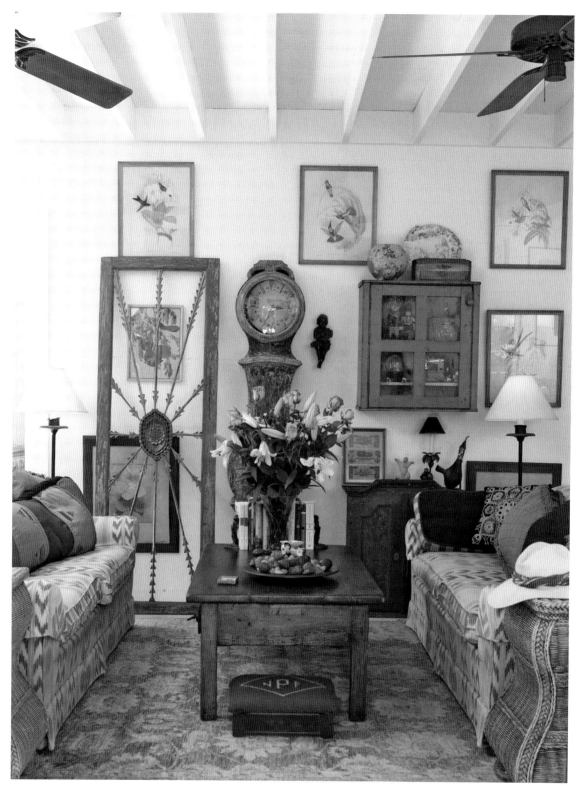

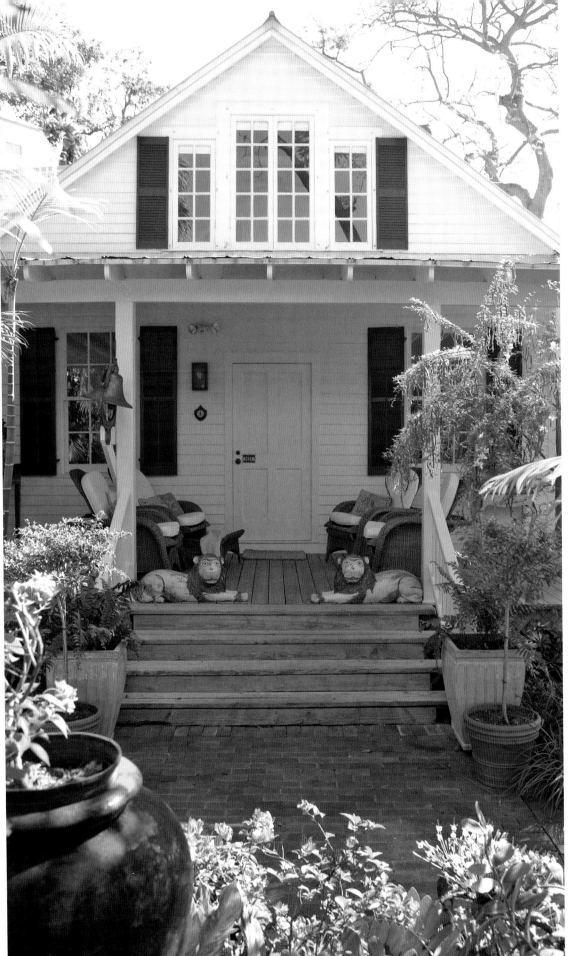

Friday calls this "my secret
garden," also the title
of one of her books. The
outdoor space continually
evolves and changes.

Friday admits to not being an early riser and takes her time over breakfast on the front porch overlooking the garden. From there, she moves on to her custom-designed office just off the porch. Light breezes flow through it, and palm fronds can be seen from every window. "I love working here," she says. "I work from around nine or nine thirty until about two or three in the afternoon. When I need a break," she continues, "I run next door to Dick and Bob's and we have a few laughs. Then I go back to work refreshed." Because she lives right in the heart of Old Town, she walks or uses her bike to do errands.

The house was built in the late 1800s and later renovated and added on to. Doors are always left open whether Nancy is in or out.

The house is filled with a riot of color. There is an array of Moroccan pillows on the two sofas, fabulously faded Persian rugs on the floor, and early-nineteenth-century hand-colored bird prints on the wall. A Swedish clock, painted cupboard, and several folk-art objects also adorn her home. The arrangements appear so perfectly casual as to have happened quite by accident, but this sort of comfortable decorating takes a practiced eye and a feeling for what works. Some of the collectibles come from New York, others from London, many from India and Sweden. Vases of fresh flowers sit on every table. Kelley sums it up when he says, "This house has such a lovely attitude."

Acknowledgments

When we began this book, it was our intent to find twenty to twenty-four houses in different parts of the island to represent the various architectural styles in Key West, as well as those houses with the most creative interior designs. I am lucky to have cultivated so many incredibly talented and generous friends on the island over the years, and it was to them that I turned for recommendations. After spending a month looking at potential houses to include in this book, it became apparent that we could have filled two or three books. We found it difficult to narrow down the list of houses whose architecture and interior decor and owners' lifestyles epitomize Key West today.

My husband and partner, Jon Aron, is a photographer and art director. He anticipated how difficult it would be to balance the incredibly brilliant lighting of Key West with the interior lighting of each of the houses. For this project he contacted just the right person. Terry Pommett is a photographer we have worked with on our hometown island of Nantucket, and we were fortunate that he was available to work with us on this project. When we were finished, we all agreed that it was the best project we had ever worked on and felt as though we were the better for it, both professionally and personally. Best of all, we made a whole bunch of new friends.

I am most grateful to the people who allowed us into their homes and shared their creativity, their ideas, their lifestyles, and their feelings about what makes Key West the best place to live. It is with the utmost respect that I thank the following people who never hesitated to share the names of those they thought to be creative or who had houses worthy of representing a place they know, love, and care about. I first met Trip Hoffman and Alan Van Wieren when I was working on *Key West Houses,* and we have been friends for more than fifteen years. I am most indebted to them for steering me to their talented colleagues and

friends and for sharing their own inventive style. Through my good friends Richard Kemble and George Korn, I met architect Guillermo Orozco, who very generously opened doors to his projects. We also met Lynn and David Kaufelt when we were working on *Key West Houses,* and over the years we have admired their dedication to the island. I have only the highest regard for Lynn and knew before I saw the houses she recommended that they would make a wonderful contribution. I am grateful for those introductions.

The following people have given generously of their time and have graciously allowed us to photograph their homes: Joan and Stephen Wood "Woody" Cornell III, Guillermo Orozco and Kent Ducote, David and Lynn Kaufelt, Michael Pelkey, Lynn Sherman and Leonard Reiss, Jane and Tom Vetter, Betsy Smith, Barbara Sowers, Trip Hoffman and Alan Van Wieren, John Dell and Barry Philipson, Richard Kemble and George Korn, Blair Gordon and John Alvarado, Claudia Miller, Bob and Margo Alexander, Robert Alfandre, Nancy and Tim Grumbacher, Alexander Baer, Gerald and Carole Fauth, Pat and Phil Timyan, Jon McIntosh, Richard Vincent, Dick Duane and Bob Thixton, Nancy Friday, and Kenneth Weschler.

I would also like to thank the people who helped us in other ways: Suzanne Brown for her creative flower styling, Joseph and Jonathon at House Key, the folks at Small Chef at Large Catering, architect Michael Ingram for his time during a busy schedule, and my assistants, Lauren Beers and Maria Chakarova, who kept my life running smoothly. Most of all, I want to thank our friends Carol and Karl Lindquist for introducing us to Key West and for their continued support of all our projects.

I am most grateful to Andrea Monfried, my editor at The Monacelli Press, for sensible and sensitive editing and to Elizabeth White, Managing Editor, for moving the process along so smoothly. Thanks also to Christine Moog for her considerate book design and, finally, to my tireless agent, Linda Konner, who made this project possible. *L. L.*